CRITICAL ACCLAIM FOR ERIC WRIGHT

From Canada...

"Eric Wright turns out detective books that are to the crime novel what John Le Carré's books are to the espionage genre."
—*Quill and Quire*

" 'Deceptively simple' isn't quite the right phrase to describe Eric Wright's crime novels. 'Enormously entertaining...disguisedly complex...subtly profound'... Wright's method of storytelling sneaks wonderfully thoughtful observations about the human condition under the cover of amiable mysteries."
—Toronto *Globe and Mail*

From England...

"A solid, satisfying work, full of real people in a real city, and with a good surprise ending too."
—*The Times Literary Supplement*

From the United States...

"Wright demonstrates a sure knack for capturing the way people talk, think, and behave.... In Charlie Salter, Eric Wright has created a hero who is both credible and a recognizable human being."
—San Diego *Union*

"The plotting is impeccable and the characters nicely fleshed out; there is a highly civilized feeling to the books."
—*The New York Times*

"Dare I invoke the sacred name of Georges Simenon in describing Wright's way with police procedures and his touching humanity with his characters?"
—Hartford *Courant*

"A pleasure...not to be missed!"
—Washington *Post Book World*

THE KIDNAPPING OF ROSIE DAWN

The
KIDNAPPING *of*
ROSIE DAWN

A JOE BARLEY MYSTERY

Eric Wright

A PERSEVERANCE PRESS BOOK
JOHN DANIEL & COMPANY
SANTA BARBARA, CALIFORNIA · A.D. MM

Copyright © 2000 by Eric Wright
All rights reserved
Printed in the United States of America

A Perseverance Press Book
Published by John Daniel & Company
A division of Daniel & Daniel, Publishers, Inc.
Post Office Box 21922
Santa Barbara, California 93121
www.danielpublishing.com/perseverance

10 9 8 7 6 5 4 3 2 1

Book design by Eric Larson
Cover photo by Chris Cheadle

LIBRARY OF CONGRESS CATALOGING-IN-PUBLICATION DATA
Wright, Eric, (date)
 The kidnapping of Rosie Dawn : a Joe Barley mystery / by Eric Wright.
 p. cm.
"A Perseverance Press Book."
ISBN 1-880284-40-5
1. English teachers—Fiction. 2. Missing persons—Fiction. I. Title.
PR9199.3.W66 K54 2000
813'.54—dc21 99-050577

To all part-time, permanent, sessional lecturers,

wherever they may be.

THE KIDNAPPING OF ROSIE DAWN

Chapter One

THE STORY begins with me in bed, waiting for the noise of the vacuum cleaner to stop and for the sound of Helena's footsteps to fade away down the stairs. Helena is our cleaning lady, and this was her day; she had reached the door of the bedroom and was now manoeuvring her machine around the small landing.

I had slept late, and now I was paying for the eleven beers I had drunk the night before, trying to be hospitable to Boris when he called by. Boris is an old friend who lives in Newmarket and teaches at York University. He has made something of himself since we were in graduate school together, and now he has his feet

planted firmly under the high table of academe. But his origins
are as humble as mine, and there is an overlying tension between
the barefoot boy that was and the suede-footed Cambridge gradu-
ate whom the world sees now. He gets relief from this tension by
calling on me late at night and drinking beer and telling "when-I-
was-a-kid" lies in the dialect of his youth. This usually occurs after
an evening of, for him, proper academic relaxation, listening
to a visiting lecturer on "Fictive Strategies in *Romola*," say. Duty
done, he buys a case of beer and knocks on my door, and we drink
it together. All twenty-four bottles.

Thus it was that the morning after one of Boris's calls I was
lying in bed calculating that I had about two minutes to get to the
bathroom across the landing or die. The trouble was that my
bathrobe was on the back of the bathroom door where I always
leave it. When I wake up, I cross the landing naked, pee, collect
my robe from behind the door, go downstairs, eat breakfast, come
back upstairs, hang my robe behind the bathroom door, shower,
shave, and recross the landing, diagonally this time, to get dressed
in my office where I keep my clothes, the bedroom being too
small for my bureau. The only problem, on alternate Thursdays,
is Helena, a nice woman who might be shocked, offended, or
simply disgusted to find herself employed by a naked landing-
crosser with a full bladder. I'm not sure. The problem has never
cropped up because I've always been able to wait until the coast
was clear.

Now, though, my two minutes was up; I gave in and pulled on
my pants. I hate wearing my trousers raw, but the alternative was
to put on yesterday's dirty underwear, now buried in the clothes
basket on the other side of the room, a lot of trouble for a trip of
just five steps. Outside, the vacuum was still whining, and I now
wondered if Helena was demonstrating how scrupulous she was.

There couldn't be that much detritus in four square yards of scarred wood-block flooring with an oval braided rug in the centre. Then the machine started banging against the bedroom door, casually, clumsily, but too often, and I got the message. The hall was clean; now she wanted to get at the bedroom. I was interfering with her work, and she was getting impatient.

I was shocked. We had only had Helena for about six months, but until now she had been a model skivvy—subservient, hardworking, always refusing offers of tea or coffee in favour of continuing to work, and at first with just enough English to understand what was required without being able to sustain a conversation, or more important, believe that she could. Once, crossing Alberta by bus in pursuit of work in Edmonton, I was talked at all night by a lonely Bavarian pastry-cook in what he believed to be English. I couldn't understand more than every tenth phrase, but early in the evening I had been silly enough to try to be courteous by pretending on the basis of my B in first-year German that we were having a conversation, and when dawn broke over the salt flats, he was still talking. I considered leaving the bus at Red Deer, but I had no idea how long I would have to wait for the next one, so eventually I closed my eyes and feigned sleep, aware that he was out there, waiting for me to wake up and resume our chat, like a cat watching a mousehole. I learned a lesson that night I have never forgotten.

For Helena is Portuguese, and she used to shake her head a lot whenever she didn't understand. "Helena," I would say, "have you seen my shoes?" She would smile, shake her head, and carry on cleaning the window. Then, just to test her, I would say, "Helena, have you eaten in the last three days?" and she would smile and shake her head and carry on cleaning the window. So I would point to my socks, then she would nod and smile and go

downstairs and collect my shoes from the mat inside the front door where I had left them to dry off the night before.

She is a highly intelligent young woman, and in the six months she has been with us she has worked as hard at the language as she has at cleaning floors, so that now I sometimes try for a slightly more elaborate sentence construction, teasing her a little, stretching her out. "Should I try to shower before the washing machine has completed its cycle?" I ask, and she will say, "Sure, go ahead," smiling a "try-me-again" smile.

We employ her illegally, but since no one in the house plans to run for attorney-general, it doesn't matter, except to Helena, for whom it's a better job than most of her legally employed friends have. We ought to be paying unemployment insurance for her, needless to say, and two per cent for vacation pay, but we don't because she doesn't want the authorities to discover her and ship her back to the family farm in Portugal. So every other week we pay her fifteen dollars an hour for six hours' work, and give her an extra ninety dollars in the summer and at Christmas in lieu of holidays, an arrangement she prefers. She likes us, I think, and she trusts us. (She has had two bad experiences of employers' threatening to report her unless she worked harder for less money.) She is an alien, then, who means to be grammatically ready or at least not disadvantaged when they offer her the possibility of legitimising her status. All this lies behind why she was banging my door with her vacuum cleaner and why I had to put on my pants to go to the bathroom that morning.

When I came out of the bathroom, in my robe, she was still there; now, obviously, waiting for me. "I make you coffee, Mr. Barley?" she asked.

I was nonplussed, the first time I can remember feeling exactly like what that word means. She had never made coffee for me

before, or even agreed to sit down across the kitchen table and
share a cup. Could it be a Portuguese euphemism? ("I want you to
try my special grind!") Surely not. Whenever in the past I had ac-
cidentally brushed a corner of her strike zone, there had been an
instant recoil on her part, not fearful or personal, or offensive, but
as if a snail had sensed something white-hot in its path. Part of her
culture training. On the other hand, she presently obviously needed
to waylay me, which was, I finally saw, what the vacuuming inci-
dent was all about. "Sure," I said.

She hung the vacuum hose and cord around her neck. "You
wash," she said. "I make coffee."

Now, this was not my way. First thing in the morning I need a
print fix, something to read. And no talk. Some days my need is so
fierce and indiscriminate that I will even get through the colum-
nists in the business section of the *Globe and Mail*; print, in some
form, is as necessary as the orange juice, the two cups of coffee,
and the one slice of toast that I absorb before I can think about
washing or shaving, or talking.

But Helena was setting me up for talk, I could see. There was
nothing I could do: she had a problem and I would have to listen
and tell her I know nothing about the Immigration Act or the
Landlord and Tenants' Act, or how to collect on an employer's
bounced cheque, some of the likely hazards in the minefield of
her day-to-day existence. And I wondered why she hadn't spoken
to Carole, the lady I live with, before she left. Simply as women,
they had developed a tiny kinship that made for more of a bond
than I had with Helena.

Chapter Two

WHEN I came out of the bathroom for the second time, clean and starving, I heard the toaster in the kitchen ping, and by the time I was dressed and seated at the table, shivering slightly, Helena had poured my orange juice and coffee, and presented me with a slice of toast. Then she sat down across from me.

"Mr. Barley," she said. "You are secret policeman."

Stressed as I was, aching for some words to look at, I started to laugh.

She said, "No, no. Not for government. I know. I mean you are policeman in secret."

"I'm a teacher," I said, turning my head sideways slightly, trying to read the list of contents on the marmalade jar without being obvious about it.

"Oh, sure. I know. But the lady said you are also..." She paused, searching for the word. "Detective. Right? You detective."

"Helena, I work for a company. No. Agency?"

She nodded. *"Agência,"* she confirmed.

"Okay. I work for *agência* like you work here. Just a little bit. Not much. Not all the time."

"But sometimes you are detective."

I gave in. "Well, sort of. Okay."

The truth is that I am sometimes employed by a security agency as a watcher. I sit and watch a door, or a street, or a parking lot for up to eight hours and tell the agency whom I have seen in that time. That's it. I just report what I see. For this the agency charges the client fifty dollars an hour and gives me twenty. (The agency consists of a former Metropolitan Toronto policeman in his sixties and his forty-year-old unmarried daughter. They aren't very aggressive, but they make a living without too much effort by employing people like me.) Most of the work comes from insurance companies, trying to prove the illegitimacy of compensation claims. Apart from insurance jobs, I've been hired twice by women who were curious about their lovers' lives, women who suspected they were being lied to and were concerned about sexually transmitted diseases. Mostly, though, I just watch people who claim to be paralysed, try to take Polaroids of them clog-dancing at ethnic reunions.

As an agency, we watch and follow, but as an agent I just watch, a part-timer hired to work a shift. Only the full-timers follow, because following can entail driving to Buffalo, and working overtime. I can't do that because of my other job.

I also teach part-time at Hambleton College, a satellite college of a university, a place where I have a permanent part-time job that doesn't pay me enough to live on but leaves me lots of time. So there you have me: Joe Barley, permanent part-time sessional lecturer in English, and occasional temporary employee of a security agency. (A sessional lecturer is one hired for the session, and a permanent sessional lecturer is one who is rehired every session.)

I said, "Sometimes I watch people who do bad things."

This was old-style Helena-talk, invented in the early days of her employment by us, and still dropped into when a new subject requiring an expanded vocabulary crops up.

She nodded. "You must help me," she said.

This was the next grade up of Helena-talk, a stripped-down language with an oddly archaic feel. Helena still uses phrases like "I go," and "I cannot return next week," and "the snow falls heavily," as if she had learned English by reading Rider Haggard or John Buchan.

I steeled myself for a request for money. Although Helena seems frugal and self-reliant, living and working as she does she has no financial safety net, nothing that a periodontist, say, would bother folding into his wallet.

"What's the problem?"

"One of my ladies is gone away."

Helena works for five people directly, a half-day a week for each, and is sub-contracted to at least two other Portuguese cleaning ladies who have more work than they can cope with but do not cut back for fear they might one day be short of work. In Toronto a whole network of Portuguese cleaning ladies trade work among themselves, usually involving cleaning apartments along Bloor Street that are maintained by companies for out-of-town guests. We know from Helena's predecessor that these company jobs are

much sought after because, although the cleaning lady is paid every week, sometimes there is nothing to do because the apartment might not be used for months.

"Since when?"

"Already for two weeks."

The problem with Helena-talk is that you can't bat a few sentences back and forth until you have figured out something relevant or interesting to say. You have to think first, and there are gaps while you do so. "Why is this…" I began, launching into a sentence before I had found the Helena-word to end it. "Not normal," I concluded. "Strange," I offered, as a gloss.

Helena got it. "Before, she always said, and she paid me. Now she just went."

"Without leaving your money."

"Without?"

"She left you no money?"

"Yes. No. She left no money."

"Is there no one else in the house?"

"She lives in apartment in Albany."

Not the capital of the Empire State, but an apartment block that fronts on Bloor Street.

"By herself?"

"Sometimes." Now Helena blushed slightly, then shrugged. "I think a man pays the rents."

Kept? What was Helena-talk for *kept*? The word is drifting out of fashion, even among Anglos. Helena would certainly only understand it literally.

"A sort of boy-friend?" I asked.

"Not boy-friend. He just pays her to…do things."

I couldn't resist it. "Like what?"

"He sleeps with her."

I was hoping for a little bondage, at least.

She continued. "She lives somewhere else. The apartment is just for fucking." She went scarlet.

I smiled to show how commonplace was the situation she was describing, and also how unshocked I was by her choice of vocabulary. "So now they've stopped. She has gone away, not to see him any more. That's all."

Helena shook her head. "Sometimes she stay in the apartment without him. She has some clothes there, and food. Little bit. Not much. The clothes are still there, and the food. And she has left me no money. She not like that."

"Who is the man? Do you know?"

"I think I saw him. Once I lost my Metro subway pass and I went back to the apartment in the afternoon, to see if I left it there. I opened the door with my key and he was in the hall, just leaving, I think. She didn't say who he was, but she was angry with me. I thought I lose the job, but she's a nice lady. It wasn't my fault."

She shook her head as if still arguing with herself.

I came to the point. "What do you think happened to her?"

"Yes. I think something happened to her."

"What?"

"I don't know. Maybe she got into an accident."

"What's her name?"

"Dawn."

"Dawn what?"

"Miss Dawn."

"What's her first name, then?"

I could ask the police about her, tell them the reason. If your cleaning lady reports a missing person, then the cops ought to be told. I didn't think they would enquire into Helena's immigrant status.

"Rosie," Helena said.

Now I was less keen to talk to the cops. I had heard that at least one of Metro's finest is a poet, and asking him if he had a woman called Rosie Dawn on the books was likely to be a memorable enquiry. "Was the middle name 'Fingered' by any chance?" I could hear him saying. On the other hand, the coincidence of my being asked to look for someone called Rosie Dawn at this point was fascinating.

"I don't think that could be her real name," I said to Helena.

She shrugged. "I call her Miss Dawn. A nice lady. I don't care what she does. She was nice to me."

"How does she sign her cheques?"

"I don't know."

"How does she pay you?"

"She give me money." She waited to see if I understood. "How much, you mean?"

"No, no, but when she was not there, did she leave the money in an envelope?"

"She was always there when I cleaned. She likes to talk to me."

"What about?"

Helena went pink. "Ladies' talk," she said shyly, but smiling a little. "About men. Sometimes we watch a little bit of television and talk about it. That man in the audience with the microphone. All those men who have become ladies."

"Did you ever see her outside the apartment?"

"No."

"Do you think she has other men?" Under the guise of thoroughly questioning Helena, I was being a little prurient, but it was interesting.

"I don't think she is a…*prostituta*."

"But she *is* a mistress."

"Pardon?"

"She does sex for money, but only with one man at a time."
Now *I* blushed. "I mean…"

Helena grinned suddenly, making me conscious, not for the
first time, that I might be underestimating her savvy. "I know," she
said. "No, no other men, I think."

"Do you know anything else about her? Does she have a family,
children? Does she get phone calls? Do you know where she lives?
Did you ever see a street-car transfer? Anything?"

"Nothing. She never get phone calls."

"Not one?"

"Not when I am there."

"But there is a phone in the apartment."

"Oh, sure, but if it rings she does nothing, never answers it.
Says to me, it must be a wrong number."

"That's all? She just watches television and ignores the phone?
Lets it ring?"

"Some days she writes in her book. She has a book in her purse
to write things in."

"What kinds of things?"

"I never saw them. She kept the book in her purse."

"And then one day she was gone? How long now? Two weeks?
When do you go to her again?"

"Yesterday. Yesterday she wasn't there for the second time. Not
slept there, not used the towels."

I sipped my coffee. "I don't know what to say, Helena. I can try
to find out if she's missing, or I mean 'found', I guess. But then the
police will ask you to say what you remember."

Helena started to shake her head and made decisive dissociat-
ing gestures with both hands. "No way."

"They won't worry about you," I said.

"They'll make me go back to Portugal. No way."

"I don't think they will. You haven't done anything."

I was just guessing, though. I had no idea what happened to illegal immigrants from Portugal, or what it was like to be one. I said, "Helena, I have to give a lecture at eleven. I can get back by one o'clock. We'll take it from there."

"I'll stay here until then," she said promptly. "I'll wash the curtains."

"There's some ham in the fridge, I think."

"I don't want anything." She stood up. "What time we meet this afternoon?"

Helena has never accepted any of our repeated offers of food. We thought once she was shy of sitting down with us, but I am beginning to suspect she finds our food unappetising, though I have never heard that Portuguese cuisine is very distinguished— salt cod for Christmas, that kind of thing. It may just be, though, that she is afraid we'll deduct it from her wages. From what she has told us of the experiences of her friends, she would not be surprised.

"I'll meet you outside the Albany at one-thirty."

Finally she went back to work and I was able to read a story in the *Globe*. It wasn't riveting—something about a change in the rates railways were planning to charge to ship grain to Medicine Hat—but it soothed me enough to restart my morning's routine.

Chapter Three

I SHARE an office at Hambleton College with Richard Costril, another permanent part-time sessional instructor, a small, square man with black hair, a thick moustache, and heavy eyebrows, all of which seem to be glued on to a dead-white skin as if by a make-up person at a straw hat theatre who was trying to create a crude impression of villainy. Richard, as far as I know, does nothing illegal, but he is certainly black-hearted, as he would agree. He is made so, he would add, by the administration of the university, the dean of the college, the chairman of the department, and by his colleagues, as well as, in his non-professional hours, by

whatever federal, provincial, and municipal politicians are currently deforming his life. To begin with our status, his and mine, and to describe it from Richard's point of view, we are the victims of academic apartheid.

It came about because once upon a time the universities realised that part-timers were cheaper and provided more flexibility; that is, they were easier to get rid of than tenured faculty. This took place in the sixties, well before industry had the same idea, and for a while the universities happily cut their labour costs in all the ways that were available to them—the use of "teaching fellows" (these were the pioneers), sessional appointments, part-time appointments, and markers. But just as the universities were realising what a huge pool of cheap labour they had to call on, the revolutionary atmosphere of the sixties began to affect the non-tenured faculty, as they were collectively called. These *sansculottes* now organised themselves, created their own unions in imitation of the faculty associations that represented the full-time, tenured faculty, and bargained for their rights, some of which they won, including a kind of job security, but not including the salaries, the working conditions, and many of the employee benefits of the regular fat-cat faculty. The result is apartheid, two groups of instructors doing identical jobs for very different wages and under very different working conditions.

Thus a monster was created called Richard Costril, a man who has since dedicated his own life to making miserable the lives of all the hypocrites who support the system, that is, everybody else in the college, mostly all the full-time faculty. The tenured faculty would like to be rid of him because his moral position is impeccable, and he is constantly reminding them that theirs isn't. Whenever one of his tenured colleagues is reported as having joined a human rights protest of any kind, Richard cuts out the report and

puts it on his colleague's door with a crayoned slogan, OPPRESSION
BEGINS AT HOME. He writes continually to the student newspapers
on the subject and every year the new editors publish everything
he sends them. But since he has seniority over the other five
sessionals in the department, he is immovable.

And where do I stand on all this? Why am I not raging, too?
Because if you aren't raging, in Richard's view, then you are kiss-
ing ass. In theory I am right in there with Richard. In practice,
too, when a crisis occurs, usually as the result of the administra-
tion trying to cut our wages or erode our contract in other ways. I
parade, with a sign, whenever the buggers have to be brought
back in line. But the truth is that for most of the time, the appall-
ing, iniquitous, shameful situation that is a stain on every partici-
pating university in this province, and for all I know in the other
nine, too, a situation that makes a mockery of every liberal
professor's stance, shaming them not only in their own, but in
their students' eyes—for the students have not failed to notice that
good and bad teaching can be found at all levels, at all prices—
most of the time, I have to say, it suits me very well.

To understand this you have to know that I found out within a
year or two after my short stay in graduate school that I am no
scholar. I have no taste for the work and no aptitude. I am a
teacher, though, good enough to be worth my pay. But universities
are for scholars, real and quasi, both those who burn with a pure
gem-like flame, and those who can scrape together enough facts to
support a manufactured argument to earn a degree, and then turn
the thesis into a book, and then publish an article by the same
method, about once a year. (Don't be too hard on them; it's a
dog's life, doing work for which you have neither the taste nor the
talent, when you could more usefully spend your time teaching,
like me.)

So I left graduate school with my thesis still to do, picked at it over the next three years, trying to keep the sap rising, until I became sure that I was never going to write it. Meanwhile I came here to earn some bread, liked it, and I've been here ever since.

So I've escaped a dog's life. You see, they can't demand of us part-timers that we publish, because they don't pay for our time outside the lecture room, time we use in doing other day labour to support ourselves. They own us only for the time that we teach. That's how they justify the low wages. They can't get rid of me easily, either, because I am senior after Richard and so, to get to us, me and Richard, they would have to start at the bottom, getting rid of the just-hired part-timers, then the latest term appointments, and finally the sessionals, before they arrive at me, and without that lot they couldn't get the teaching done, not for twice the price, without doing a lot more work themselves. So it's a situation that suits me perfectly, and I don't go out of my way to give the authorities a hard time.

Richard, on the other hand, does. In point of fact, it suits him perfectly as well, because he's no more of a scholar than I am, but he nurses a purer rage about the injustice of his situation than I do, never letting the bastards in charge forget their hypocrisy and moral turpitude for more than a day at a time. He began by being genuinely angry; now he enjoys the anger for its own sake. He feels that in continually roasting his colleagues for their shoddy morality, he is being true to his principles. He's impossible to get rid of, and provided they don't offer him a tenured position (which, given the continual scourging he inflicts on them, is very unlikely), he can continue indefinitely to make their lives miserable.

As for me, I am still trying to decide what to do with my life. I drifted into English Studies because I like reading, and I stayed in it because I like teaching. I have no theories about literature, and

in my present situation I don't need any, but I have to plan be-
cause they'll win in the end. My old Dad says they always do, and
one day they are going to be able to use my ignorance of the prin-
ciples of post-structuralism or oral hermeneutics or whatever the
fuck they'll be up to by then to get rid of me. In the meantime, this
suits me very well.

~

Richard was already in the office when I arrived, talking to a stu-
dent, so I got my books together and walked over to the cafeteria
to drink coffee until it was time to teach. There is often a certain
amount of role-playing involved in talking to students.

Actually there are two kinds: there is the performance put on
for the student, and there is the one intended to be overheard by
one's colleagues. Richard went in for the second kind, playing the
brutal inquisitor for the benefit of anyone passing along the corri-
dor. There is no substance to his act; I shared an office with him
for only a week before I realised he is liked by most of his students
and feared by none. I try to leave him his office free to perform in,
though, especially when I have nothing to prepare.

That morning I was teaching a course called The Forms of Lit-
erature: It begins with the epic and ends with the novel and in-
cludes a look at drama, lyric poetry, and the short story. To be
specific, after a couple of hours of short stories, making sure that
all the students are in the right room and there is no one there
who thinks I am introducing them to Macro-Economics, we move
on to the *Odyssey*, and soon dawn appears with rosy fingers, which
is why, when Helena told me the name of her lost lady, I, too, was
lost. It was an irresistible message. Go find her. Surely the gods
were casting my fate.

The term was a month old and we were heading for Odysseus's
confrontation with Penelope's suitors for, in my case, the seventh or

eighth time, so I just had to glance at my notes to remind myself of last year's insights, and I could then lecture while I thought about Helena's problem.

I was guessing at this point that she was worrying about nothing. Someone had installed a bimbo in an apartment. After a while, one or the other had got fed up with the arrangement, and she left. The clothes would be picked up later, or not, if they were simply the rags of lust. If he had paid for them, he might have been vindictive enough to have demanded they be left behind, ejecting her naked, in a metaphorical sense.

After about five minutes of double-track thinking, about Helena on the one hand and about Odysseus on the other, I became aware of a student asking a question about Odysseus's age, surely old in Greek terms and middle-aged in ours (ten years older than me, at least), but in his Greek prime apparently for the purposes of fighting and screwing, and we spent the rest of the hour on that, agreeing finally that Odysseus was as he was because Homer himself was probably in his late forties. Helena was forgotten, while the students eyed me speculatively, guessing my age, wondering if I could still get it up.

A student was waiting for me after the class. He wanted me to reconsider the grade I had given his essay, an F, but there was nothing to reconsider. The essay consisted of a desperate two thousand words on the first four books of the *Odyssey*, patched together from *Coles Notes*. When I asked him if he had read the text, he said, quite simply, that he had not been able to. I told him I was sorry that I couldn't find anything to grade, and he left.

Richard, who had been listening, pounced on me. "You were kind, weren't you? He practically copied it out, didn't he?"

"I gave him an F. A zero."

"But you did it *kindly*."

"My father always used to say, 'Give them shit, or fire them. Not both.'"

"Is that true?"

"You mean is it true that my father used to say it, or is it a useful rule?"

"Both."

"Actually I heard it from a foreman of a road-building company, but I polished it to its present form because I thought it sounds better to begin, 'My father always used to say…'"

"The phrase is from the opening of *The Great Gatsby*."

"Yes? That's why, then. As to its ultimate veracity, it's an interesting idea and Voltaire once said that it's better for an idea to be interesting than true. Lots of things I say in class are not true, but they are interesting. Like the theories of Freud."

Richard had heard this rubbish before, but I was showing off now, talking for the benefit of a third person, a man from the psychology department who was standing in the doorway. "Sorry," I said, affecting to notice him now. "Can I help you?"

"What does 'egregious' really mean?" the psychologist wanted to know. "Can I use it in a positive sense? The truth, please."

This man came to us about once a week with a question like this. Richard believed he was ashamed at having silently connived at our inferior status—the man had tenure—and was continually trying to ingratiate himself with us to show where his true sympathies lay. I thought myself that a simpler, more old-fashioned explanation was likely: as a psychologist, the man felt himself to be a fake, his discipline cobbled together out of the insights of Shakespeare and Homer, and he yearned to be accepted as an honorary member of the English department, like an auxiliary policeman.

I left him with Richard and went off to meet Helena.

Chapter Four

SHE WAS waiting for me outside the Albany apartments. There was no security except the locked outer doors, which could be opened by anyone pressing a few of the buzzers at random until someone answered. Helena used her key and I followed her into the elevator and up to the fourth floor. This was not a family block, and most of the tenants must have been out working because we met no one on our way in.

The apartment block had been recently refurbished and modernised. The outer doors were made of smoked glass and steel; the elevator had an art deco look, and the lobby and halls

were newly carpeted. The rents, therefore, had certainly been jacked up to pay for the renovation. Rosie's apartment had a slick-looking shower cabinet, and the bathroom taps were cast in the shape of swans' heads. The kitchen, too, was fitted with this season's appliances, including a tiny German washer-dryer unit. Clearly Rosie was no seamstress to be kept in a rat-filled attic and rogered for the price of a bottle of the widow.

I started at the only bedroom. The few clothes in the closet looked as if they had been left behind by a previous tenant, and the bureau and the bedside table were both empty. I moved to the kitchen. The drawers held a few implements and some cutlery, but there was no other evidence of any cooking. The fridge held a tiny container of yoghurt, half a litre of Lactaid, and two old croissants. In the canisters on the back of the stove I found five tea-bags and a jar of instant coffee.

The living room was furnished, but only like a furniture show-room. Even the pictures looked as if they once decorated a booth at the Home Show. The living room had been allocated a couch, two armchairs, a coffee-table, a television set, a small dining table with four chairs, and a small rug.

"This place is a hotel," I said.

Helena waited for more.

"Your lady, Miss Dawn, doesn't live here," I concluded aloud.

"No, I said so. She came here to…"

"Do bad things. I know, but you don't know where else she lives?"

"I just know her here."

"Then that's it, I think. She doesn't do bad things here any more. Now he does bad things with someone else, somewhere else."

She waited, unsatisfied.

"Does she have your number?"

"No. I give her Maria's number."

Maria is her mentor, the lady who first found Helena work when she arrived from Portugal. Helena lived with Maria's family for a while and even though she now has her own place, Maria still takes phone messages for her from people who knew Helena before she had her own telephone.

"She never phoned Maria," Helena added.

"Has she ever gone away before?"

"No. But I only work for her maybe four months."

Just then a key turned and the front door opened. A very thin, bald man wearing a waistcoat over a dirty T-shirt, greasy trousers, and carpet slippers walked in. "What's your name?" he demanded, like a shopkeeper interrogating a thieving schoolboy. It almost worked, too, but the instinct to lie came in time. I looked through the window to the street behind the building. "Charles," I said. "That's my *last* name. Who wants to know?"

"I do." He moved to the door as authoritatively as a man in greasy trousers and carpet slippers could manage. "I want you outside."

"And who are you?" It was obvious enough, but I was trying to figure out what was odd about him. As he spoke again, I saw that it was the lack of tentativeness on his part. He had no idea who I was, but he had no doubt I didn't belong there.

"The superintendent," he said. "And the present tenant has requested that I maintain a watch on this apartment to obstruct breaking and entering."

"Where is this tenant? Who is he?"

"The answers to neither one of them questions is your business. What are you doing here?"

"This lady cleans the apartment. She hasn't seen her employer

lately, so she asked me to come with her today to find you. To find out if there were any orders for her. Her English is not as good as yours and mine."

He swelled like a bladder. "Usually the way with the people they're letting in these days. That's the problem. Yes, I do have a message for her. She won't be needed any more. All right? Here." He pulled an envelope from his waistcoat pocket and offered it to Helena.

I looked at her to see if she understood. She nodded.

"And the lady she cleaned for? Is she the tenant?"

"She is not. She is no longer in residence." Then this dirty, puffed-up, pompous dink added, "Are you coming, or do I have to summon the authorities?"

"How do you do that? With a gong?"

But I was wasting my time.

～

As we left the building, I took a look at the name board, then found a phone box in the street and called the superintendent. "This is Apartment 402," I said, in an Irish accent I've received compliments for. "I'm a guest here from overseas, and there is no one at home at all. Thing is, d'ye see, there's water coming through the ceiling and there's this big bulge in the plaster— whoops, there she goes. A Christly flood is what we've got now. You'd better skeedaddle up here, quick. The apartment over me head, I mean."

I ran back to watch through the glass door, saw the elevator descend to the basement, then start on its journey to the fifth floor. I let myself in the front door with Helena's key and raced along to the mail room. The box of 417 was stuffed full with second-class mail and fliers. The name on the box, written in pencil, was BLUNCH. I was back outside before the elevator came down.

I walked Helena over to Bay Street. She lived in the Portuguese
district, way out on Lisgar, where it crosses College. She could
catch a bus on Bay south to College, and I could drive north on
the same route. I live in the Annex in a four-plex on Howland
near Dupont, a district without cultural identity if you don't count
the high proportion of homeopaths and people in therapy.

There were five twenties in the envelope Helena showed me at
the bus stop. "You think Miss Dawn's okay?" she asked me, want-
ing the answer *yes*, which I gave her. She nodded. "Okay, then. See
you next week. Thank you." She crossed Bloor to wait for her bus
outside David's.

~

"There are a number of features of the case that interest me," I
said to Carole over our microwaved casserole that night.

Carole can't cook, I'm afraid; she can't do anything much. She
can't garden, or sew her own clothes, and she's shown no flair for
decorating the apartment. If we got spliced, it would be a
marriage of convenience foods. Our nearest approach to a live kit-
chen is on Saturdays when we eat bacon and eggs. Sunday nights
we usually eat ethnic, somewhere along Bloor Street. It's a healthy
diet, short on natural roughage, but without rich sauces, and the
morning bran in the orange juice goes some way towards making
up for the lack of fresh vegetables, excrementally anyway. (Carole
read somewhere that stools should be large and floating, and so far
we have avoided the extremes of concrete and airborne.)

"In the first place, some emergency must have occurred that
made it impossible for Rosie Dawn to lay Helena off in the ordi-
nary way. Second, there was no note from Miss Dawn. Helena
and she got along quite well, I gather. There ought to have been
some kind of message. Third, too much money was left for Hel-
ena. Why? To keep Helena quiet? Or because whoever provided

the money didn't know how much she was paid? Fourth, 'Blunch' is not a real name. No one is called Blunch. I checked the telephone book. There is no Blunch listed. But there is a phone in the apartment. I didn't see it but Helena mentioned it, a phone that Rosie Dawn never answered. Why? I think I have to do a number of things, but I'll need your help."

"Yes?"

"Yes. I noticed a 'Vacancy' sign on the building. Here is the number. Phone and ask about the vacancy. See if you can find out if it's a one-bedroomed apartment on the fourth floor."

Carole closed her book, marking her place with a tooth-pick, and walked down the hall to make the call. She returned in a minute to report that the apartment was a *two*-bedroomed unit on the *fifth* floor. "Can I read my book now?" she asked.

"Aha," I said. "So Rosie's apartment is being retained. I must find out the number and call it. Whoever answers will be the new victim."

"Right you are. Can I go back to my book now?"

I sighed. Carole is not much for horsing around. She'd sooner read. In fact, as I said, she's not much for anything except reading. It's what we have in common along with movies and cryptic crossword puzzles, which she's good at, but not in thrall to, I'm glad to say. Cryptic crossword puzzle solving is the intellectual equivalent of the activity of neurotic beavers who continue to build dams in captivity. Boris, my beer-drinking tenured friend, once spent the first three months of a sabbatical in England trying to complete *The Times*'s crossword, only abandoning the unsolved portion each day when the next day's paper was delivered. It took him a month before he solved one on the day it was published. Only the threat by his wife that she would leave him if he continued made him quit, and then he only managed it by cancelling delivery of the paper.

Movies and reading are all we have in common, then; I've known couples make it to their golden wedding with less.

I met her three years ago at a book-launching party, held in the garden of a gentrified home in Cabbagetown. The novel being launched had been written by the hostess, and it touched, apparently, on the Quebec separatist question, and it included a couple of chapters set in Montreal. Carole, who grew up in St. Boniface, Manitoba, is bilingual and had been paid to verify the accuracy of the French dialogue.

I discovered her when I went the wrong way out of the bathroom. She was sitting on a couch in the study, reading, while Toronto's literati were furiously networking on the patio. I didn't find her pretty at first sight; I still don't. But I thought she had something more than pretty, call it style, though it's not style, really; she just looks like the only woman in the airport lounge you would want to sit next to all the way across the Atlantic, and I preferred that to pretty; I still do. That day she was wearing a plain grey woollen dress, sandals—the Indian kind with the bit of leather that goes around one toe—and, I suppose, underwear, but nothing else, no jewellery, no lipstick, nothing. Her hair was a feature, a mix of blond and grey, hacked very short, but shiny. The total effect was to make me want to know more about her. Later, when we moved in together, I found that all the elements of her appearance were chosen for their economy and ease of movement, especially while reading. I have never known a woman with fewer clothes. Her grey woollen dress was her only "good" one, and even I had more shoes than she did. Around the house, and outside, too, if she has a topcoat for cover, she wears a kind of linen painter's smock. She has two of these, and is able to create the impression to casual visitors that she has just been interrupted at her work in the basement. In fact, her entire non-working day is

spent reading. I'm not exaggerating. Let me illustrate with a slightly embarrassing story.

One Sunday morning we decided to go out for a late breakfast. The sun had appeared and moved the temperature up fifteen degrees the way it can in Toronto in April, and people, couples especially, were walking more slowly with silly looks on their faces, and I felt like buying the *New York Times* and going somewhere for a *café au lait* and a croissant, pretending we were in some more upmarket city for an hour or two. Don't misunderstand me: I like Toronto most of the time; you *can* buy the *NYT* on the day it's published, and the croissants and the *café au lait* are better than you will find on the Upper West Side. It's just that, eating your croissant and drinking your *café*, you know you are faking it a bit. This isn't what most people here are doing on Sunday mornings. Many of them are eating marmalade.

Feeling festive, then, Carole went off to bathe, and I followed her in and out of the bathroom. Scrubbed and shaved and anointed with a dash of Trumper's eau de cologne, I came out of the bathroom and crossed to the bedroom to be met by the sight of Carole kneeling naked on the bed, her head pointed to catch the light from the window, and her Renoiresque bottom facing me.

Now, I have no complaints about our love life; we enjoy ourselves without disturbing the neighbours, but among the conjunctions we haven't tried is the one Carole now seemed to be inviting, perhaps to celebrate *primavera*. I say "seemed" because I was simultaneously struck with the alternate possibility that she was feeling larky and pretending to pose in the attitude much represented on the covers of the top-row magazines in our local bread-and-milk store, and though this possibility was extremely unlikely I felt I ought to try to construct a witty response in case that was what she was about.

Still without having made up my mind exactly what she was about, and what, therefore, *I* ought to be about, I cradled a cheek in each hand and set my doubts aside in an overwhelming need to crush her to my rearing ugliness, when she said, "Do you mind! I'm trying to read."

Because that is what she was about. Still perspiring lightly from a hot bath, she had adopted a position that would allow as much as possible of her to dry off while she read, without getting the bed or the book damp.

(Rereading later what I have written above, I feel I have to correct a misleading impression before going any further. The above incident, though true, was shaped for rhetorical effect, to get a nicely rounded paragraph at the end. But to get that effect I see that I have created the suggestion that Carole spoke shrilly, or petulantly, and what I need is that rare creature, a positive adverbial modifier, and I can't find one that won't introduce a soggy note, damaging the effect, on paper, of Carole's remark. Let me just add then, that she spoke lightly and affectionately, and reached round behind her and held on to me until she finished the paragraph she was reading.)

Movies and books: we lead a quiet life. Carole is not a hermit, but neither is she a social animal. For the sake of a very few friends she is prepared to look up the instructions in a cookbook and the result is always eatable. "If you can read, you can cook," she says. "It just takes all goddamn day." She would rather read, but she accepts the obligation to do her share after we have been fed by all of our friends, although she expects me to join equally in the work. She doesn't like being alone in the kitchen: she's afraid of getting stuck there.

She works as a speech-writer for the provincial government. Her particular talent is to combine the ability to write good

speeches with the learning to do it in Canada's two official lan-
guages. Periodically Ontario ministers are called on to say some-
thing publicly to Ontario francophones, or even, more rarely, to
Quebecers, and as often as not Carole will tell them what to say in
English and how to say it in French. She might even coach them
on pronunciation. She is classified as a temporary civil servant, but
she thinks, and I agree, that given the level of bilingualism of the
average Ontario cabinet minister, or, to be fair, most of their con-
stituents, like me she has a job for life.

Now I said, "You can go back to your book in a moment. I
need your help. Phone that number again and ask when you can
see the apartment."

"I thought you might want to know that. I already asked them.
Anytime."

"Tonight?"

For answer, she put her tooth-pick back in the book, closed it,
and stood up. She looked down at her smock. "I'll put on a coat.
It's cool enough."

She was right. Soon I would be teaching Hemingway's "The
Three-Day Blow", in Hambleton College the first sign of fall.

Chapter Five

ON THE way over, I said, "I want you to keep the superintendent busy for fifteen minutes while I look at Rosie Dawn's apartment."

Until now, she had been doing as she was told to avoid thinking, or rather, so that she could stay in the spell of the book she was reading. Now I had penetrated her defences. "Is that really her name?" she asked.

"According to Helena. I think her middle initial must be 'F.'"

Carole said nothing.

"'Fingered,'" I explained.

"I *understand*. God!"

I didn't know if she was protesting about the name, or about my spelling it out, and I didn't ask. She can be dangerous when she is withdrawing from a book.

∼

I waited outside the apartment block until I saw her appear in the lobby with the super and enter the elevator with him. I moved quickly then, through the front door, across the lobby, then after a short, anxious wait, into the other elevator and up to the fourth floor.

The apartment was not very secure. If I knew anything about locks I could have sprung this one in a minute with my Visa card, but I had a key, so I didn't have to. Three minutes, so far. I started to work my way round the apartment, opening and closing drawers, one by one, looking through the kitchen cabinets without disturbing anything, until I realised that I didn't have to worry about covering my tracks and I moved into a speedier, less formal mode. Quickly I emptied out every drawer in the place and then went through the cupboards. I found nothing except a couple of dresses and some shoes—not even any underwear—and a lot of cleaning equipment that was supplied by the tenant for Helena's use. I did find the phone, which was in the bedroom, not beside the bed but on a bureau. There was a chair beside the bureau and a pad and pencil on top.

There was nothing between the bedspring and the mattress, and turning all the rest of the furniture upside down got me only forty-seven cents in change. Now I had been there almost too long; an imaginary noise scared the hell out of me and I left and took the elevator downstairs. I stepped out of the elevator into the lobby, almost into the arms of the superintendent. I nodded pleasantly to him, like an Irishman visiting for a few days, thought of trying a few sentences of paddy-whackery on him, but his face

registered that he had seen me somewhere before, and I was out
the door and down the street before he could organise his wits. He
would know me again, though.

~

The next morning I had to lecture on the contest of the bow, the
scene where Odysseus, in disguise, asks for a chance to bend the
bow and to everyone's astonishment does. I brought in all my
usual comparisons with Western movies they might have seen on
late night television—my own favourite is *Destry Rides Again*—but
I'm dealing with a generation that thinks Marlene Dietrich is the
one the Allies shot as a spy in the First World War, somewhere
around 1950. Even though this class tried to help me out, it was
obvious that my preparation for teaching this course next year will
consist of a summer trying to find common ground with the stu-
dents by watching reruns of Clint Eastwood movies.

Afterwards, in the office, I listened to Richard on the subject of
the federal government, which had been elected recently with a
huge majority. He has been watching them closely for the early
signs of mendacity and corruption and he got his first evidence a
few weeks ago from the Deputy Prime Minister. Having to choose
a site for the Canadian headquarters for an international agency,
she chose Montreal, saying, "At the end of the day, we are a politi-
cal party and we make political decisions."

"You see?" Richard raged, theatrical, triumphant. "We are not
to expect anything *statesman-like* from this gang of carpet-baggers.
It's not a *government.* It's a *party.* Truth, fairness, and what's best for
the national interest are all irrelevant. At the end of the day, what
matters is, 'What's in it for the party?' "

Today he has a new one. An MP has acknowledged directing
Revenue Canada to audit the books of a government critic. Rich-
ard cried, "Speak out and they send in the financial police. They

don't have to have an excuse. They can harass you for ever on the orders of some Member of Parliament who was elected by default because even the farmers he represents couldn't stand the smell of the other party."

"They could audit me in about an hour," I said.

"They aren't interested in powerless paupers," he said. "Poverty protects you."

The little alliterations cheered him up, and he wrote his words down for use in a future diatribe and went on with his marking.

The man from Psychology put his head round the door.

"Effete?" he asked.

"Exhausted by childbirth," Richard replied without raising his head. "Shares its etymological origins with 'fetus.'"

"How did you know that?" I asked, when the psychologist's head had disappeared.

"I looked up 'egregious' and started to dawdle, and 'effete' was on the page before. Where he found it."

I put a pile of essays on the desk in front of me, picked up a pencil, and thought about Rosie.

She was clearly a tart. I'm choosing my words carefully. Rosie was evidently "kept," in the old parlance, or the apartment was kept for Rosie. She put out for money. The obvious word is "mistress," but although I used the word to get through to Helena, I don't like it because I'm sensitive to the word's other connotations, shadings that include school mistress and female master, two images that quickly coalesce into a single picture of a middle-aged bond trader being caned by some old slag in a gym tunic. Already, just from the name she had chosen for herself, I thought Rosie was better than that. In other circumstances I might have called her a prostitute but that term, for me, has medical connotations (prostate, prosthesis) that preclude pleasure. "Whore" is better,

raunchier, suggesting a thoroughly dirty good time with no questions asked, yet there is also in the word "whore" an attitude assumed by the speaker, a tone of denigration, an antique flavour that goes against the times. The word "tart," though technically the same, and antique enough, nevertheless is better because it retains a hint of exuberance, a cheerful putting on of display, which the English still employ when they talk of a building being "tarted up." I think I get that feeling from Rosie's name. Surely someone calling herself Rosie Dawn has a larky streak in her? Rosie, then, was a tart who had left her place of employment and disappeared. The single clue to the identity of her employer was the word "Blunch" on the mail-box.

Just in case, I consulted the telephone directory again. There was no "Blunch" of any kind listed, although there was a café called The Brunch Box. The names on mail-boxes are usually put there by their owners, often in ink or pencil, sometimes very casually. Was it possible that it wasn't Blunch at all, but Bunch, or Brunsch, or even Brunch? Or Lunch? I looked up these names and found them all in the telephone book, including Lunch, though none of the listings was for the Albany. When I had exhausted all the possibilities of misreadings, I called in to the security agency to make sure they had no work for me for the next two days—I have to take it when it comes if it fits my teaching schedule, and at this point Rosie wasn't that important, just interesting—and set off for Bloor Street.

～

Hambleton College is in the far east end of the city, and I came back along the Gardiner Expressway and up Bay Street. There were no vacant meters near the Albany, of course, but I found a space on Charles Street, behind. I cased the Albany from the other side of Bloor Street, but there was no sign of the superintendent

lurking about in the lobby, and I crossed the street and consulted the list of properly typed names on the board in the entry.

It was worth the trip. B. LUNCH announced the name-plate, an authoritative-looking strip of metal. And then I had it. I knew already that there was no "Lunch" in the telephone book with an Albany address, and Rosie's number was therefore unlisted, but now something jumped into my mind. Once, a long time ago, when I was grubbing around in the roots of Canadian Literature, seeing if I could dig up something that I could cook up into a thesis, I came across a story called "Box Lunch" by the poet, dramatist, and short story writer James Reaney. Remembering, I rolled the syllables "Box Lunch" and "Brunch" around in my mind and asked myself if I had a clue.

I drove home and looked up "Box" in the phone book, but although there were several, none even came close to the right address. I wondered then if I had drifted into the world of computerised addressing machines, inadequately programmed to deal with anything but a normal pattern—one name, usually two initials—and realised, triumphantly, that Box Lunch had been melted down into B.Lunch by a machine that had been told that the first word in these circumstances is a given name and could be represented by the initial. So perhaps it wasn't "Box" even. But nothing would work like Box. "Box Lunch," I thought, the name of a coffee shop or some such, but why was it unlisted? Then I thought that if Box Lunch went into the machine what might have come out was not necessarily B. Lunch but, just as reasonably, L. Box, depending whether the computer was programmed to treat the first word or the second as the surname. But by now I was already going through the "L's" and I found it, "Lunch Box Ltd.", almost immediately.

It turned out to be a catering company with a plant on Eastern

Avenue, on my route between home and the college. I had a dim memory of having nearly noticed it a lot of times, but Eastern Avenue is not a boulevard to dawdle on. At one time, when Toronto was a real port, the area must have bustled, but now it is a graveyard where a few light industries scratch out a living among the trailers stored there by trucking companies. That's on the lake side. On the other side, one of Toronto's oldest and most depressing working-class districts has been settling into decay since the First World War. The streets of houses built for the original Anglo-Saxon immigrants are still untouched by the ethnic energy that has rejuvenated much of the rest of old working-class Toronto.

I found Lunch Box where I remembered. The plant consisted of half a dozen buildings sprawled out along the lakeshore; the parking lot held at least a dozen refrigerated trucks: another four or five trucks were being filled by workers with fork-lift trolleys, moving back and forth from the loading ramp like tenders provisioning ships at anchor. The colour scheme of the plant and the trucks was dark blue, with a small gold emblem that turned out to be a lunch pail enclosed in a circle. The idea, I guessed, was to create an image of up-market catering by inverse snobbery, like calling a chi-chi restaurant The Okum Inn. Deep blue and gold was the message; the lunch pail was a little joke.

I parked in a corner of the compound and walked over to a door marked OFFICE. Inside, the usual receptionist was answering phones and staring at a problem on her screen. When she looked up, I said, "My name is Fennell. I'm researching a book on company logos and I'd like very much to speak for a few minutes to whoever is responsible for yours. Your logo. I realise I should have written ahead to make an appointment, but I wasn't aware of your emblem until just now when I was driving along Eastern

Avenue and found myself stationed at a traffic light and one of your trucks pulled alongside." I smiled at her.

She looked at me for several seconds while she tried to sort this out, all the while keeping an eye on her computer screen in case it boiled over. "You want what?" she asked, finally.

"I want to speak to whoever designed your logo."

"Our what?" She touched a key on her computer, then two more, and the screen went into moving patterns like the Aurora Borealis. "Shit," she said. "Our what?"

"Your symbol. The lunch pail on the side of the trucks."

She turned away from the screen now. "The company sign, you mean?"

"That's it."

"We hired someone. An agency." She glanced back at the swirling screen and punched a key viciously to kill the pattern.

"Who hired the agency?" I asked.

"We did."

"Someone in this office?"

Her training kicked in, along with a touch of irritation. "You got an appointment?"

"No, see, I don't know who to get an appointment with. If you could give me his name I'll write and ask for one. I was just driving along Eastern Avenue, and…"

"Yeah, yeah. You said." She switched the machine off and looked at the clock. "Hang on." She disappeared into a back room.

She returned accompanied by a man in a suit, a small, bony type who sniffed a lot. He had the air of someone whose job it was to kick the beggars off the steps. "What's this you want to know?" he demanded.

I repeated more or less what I had said to the receptionist, but

more earnestly, without a smile. My instinctive resort to periphrasis as a way of preventing my listener from categorising me too quickly and just as quickly dismissing me, worked again.

"You're writing a book," he repeated, fixing on the one interesting or alien bit of information in my spiel.

"I'm doing the research."

"And you want to know who invented our sign?"

"More or less."

"I should think it was the owner, Mr. Hyde."

"It was the agency, really, wasn't it, Mr. Torgol?" the receptionist said.

"It was Mr. Hyde's idea. They just polished it up. Nothing very clever there. Those agencies make a fortune for doing nothing. Nothing. Some of the ads on TV make me weep, they're so bad. There was one last night—"

I had to cut in. "Is Mr. Hyde available?"

"Not here. His office is downtown," the woman said.

"Could I have the address? I'll write to him and ask for an appointment." I addressed myself to Torgol, injecting a bit of obsequiousness to make up for cutting him off.

Torgol considered the request, then jerked his head affirmatively at the woman. "We can do that. Anything else?"

"The name of the agency?"

Once more the head jerked. Torgol was one of those people who respond to interruptions aggressively, with a "what-is-it-this-time?" attitude, but now that I was identified as someone not in need of a job, or selling anything, he stopped snapping.

I said, "Didn't I see an article about Mr. Hyde in the business section recently? Do you have a picture of him?"

"Give him a copy of the company report, Cheryl."

She opened a cabinet and took a glossy-looking folder from a

pile. Inside was a report, also glossy, on the financial year of Lunch Box Ltd. On the inside cover of the report were four photographs of the officers of the company. Superimposed, in the centre, ringed by a circle of gold, was a picture with the caption ERNEST HYDE, PRESIDENT.

I tucked the brochure under my arm. "The agency?" I reminded Cheryl. She wrote the name on a slip of paper and I folded it into the brochure.

"What's this book going to be called?" Torgol asked.

"*Company Logos: Their Development and History.*"

"Not too exciting, that, is it? Who's going to buy it?"

"To start with, all the companies I mention, I hope."

"How much will it cost?"

"That hasn't been decided. Whatever the publishers think they can get."

I began to wonder if the idea had some real merit: it was time to leave. I shook hands with Torgol, smiled at Cheryl; then, just before I went through the door, Torgol said, "Hold on. Here's something might be useful." He opened a cupboard behind Cheryl to reveal a large stack of books, or rather, copies of the same book. He handed me one. "He had this done a couple of years ago."

It was a company history, a piece of puffery designed to show the company could afford a glossy book. Torgol said, "The first chapter is all about our leader."

They looked at each other and sniggered.

Cheryl said, "The others mention him on every page, too."

I put the book under my arm with the brochure, thanked Torgol again, and moved to the door. At that point he began preparing to make a joke. He looked sideways at Cheryl, hissed in a preparatory fashion to indicate a build-up of energy, actually

nudged Cheryl, then said, "Don't you want to know about the other fella?"

For my part I was congratulating myself on having resisted mentioning the other fella, but the response of a second banana was indicated, and I threw myself into the part. "What other fella?"

"Dr. Jekyll," he said, grinning, looking at Cheryl to include her, and waited for my response.

I counted to three, looking blank, then, "Of course," I roared, doubling up in hysterics. "Jekyll and Hyde. Right. Jesus." I left, wiping my eyes.

~

It was Friday, my turn to cook. I found a place to park on the Avenue Road end of Charles Street, and picked up some frozen breaded plaice from Marks and Spencer. We still had a few potato pancakes in the freezer as well as half a gallon of ice cream, so dinner was taken care of. I drove home and spent the rest of the afternoon reading up on Mr. Hyde.

The facts of the biography had to be dug out of a large helping of soft soap. Ernie Hyde had arrived in Canada from Belfast in 1968. He was a book-keeper then, but unable to find work in his trade, he had scraped together the down-payment to buy a catering truck, the kind that drives around to construction sites, selling coffee and snacks. By working night and day in all weathers Hyde soon paid for his truck and bought two others, and then incorporated a company under the present name. Ten years later, Lunch Box Ltd. had become one of the biggest catering companies in southern Ontario, operating food concessions in factories, schools, colleges, and sports arenas. At that point the company began to seek new opportunities, and a subsidiary was born, the Cup and Saucer chain of coffee shops. Now Lunch Box Ltd. had contracts

in six provinces and the Cup and Saucer chain had outlets in every province as well as Whitehorse and Yellowknife. Soon Hyde had branched out into garbage and wrecking, in both areas doing very well.

All this was in the prologue. The rest of the report consisted of sums, simple problems in arithmetic that, as far as I could tell, added up to the conclusion that Hyde's original investment had multiplied at least ten thousand times, its value being now about forty million dollars. Not bad in twenty-five years, starting with a second-hand truck equipped with a coffee urn and a musical chime.

Chapter Six

SATURDAY morning it rained. I chewed Carole's ear gently, hopefully, to wake her in the right mood, and soon her eyelids fluttered and I watched her face glow with pleasure. But it was the sight of the black, storm-filled sky that stirred her, not me. On a day like this she could get through half of *War and Peace* if there were no interruptions.

Carole doesn't neglect me entirely. There's a good reason we live together: I think it's love. At any rate, when it's too dark to read, she turns to me enthusiastically enough. But once, when she was sleeping and seemed to be dreaming passionately about me, I

tried to melt into her dream and she surfaced, still interfering with me, but mumbling something about having lost her place while, in her dream, she turned my pride into a bookmark. She was dreaming about reading about making love.

～

Hyde's address was in the phone book. I left Carole in the kitchen, and drove up Bayview Avenue to Steeple Chase Ride, the fatuously named row of gaudy mansions Hyde lived on. I wanted to get a feel for what kind of man I was dealing with. Every house on the street was set in extensive grounds, and each strove to be distinctive. Alone, any of them might might have been striking, set off with its own forest and waterfall, perhaps, but side by side they created the impression that the gods had been playing some form of up-market Monopoly with Steeple Chase Ride as their Park Lane.

Hyde's house was as far back off the road as any of them. It was surrounded by a pretty good hedge about five feet high, so I had to slow right down to see anything as I passed the entrance to the drive. I caught a glimpse of a huge black-and-white building surrounded by perfect lawns without any flower beds, like a nursing home for the demented rich. A Jeep-type vehicle and two big cars were parked in front of the house. I turned at the end of Steeple Chase Ride and came back to find a place to park for a longer look. Fifty feet away, on the other side of the road was a BY APPOINTMENTS ONLY sign outside a neighbour's mansion, indicating that the place was for sale. There was no sidewalk; instead, a wide grass strip separated the hedge from the road. When I wanted to, I could park on the grass strip and put my hood up, but now I just drove by. For the moment I was reconnoitering.

Just in case there was a better spot, I carried on to the intersection and brought myself up behind Hyde's house, then turned

and passed once more along the road in front. This time I slowed down to pass a car that was stopped about twenty yards away and confirmed for myself that someone else was watching Hyde's house. I've done enough watching myself to know the tricks; as I approached, the driver bent down to look at something on the seat beside him—his brief-case?—but I had him long enough in my sights to see that the gesture was evasive, designed to make him look like a salesman checking an address, as well as shielding his face. Maybe he was watching someone else, of course, but I noted the number of the car, a dark grey Plymouth. It occurred to me that he might be employed by Hyde as a guard. I'd done that job, too, acting as bodyguard. Not the heavy brigade, of course, just the interference between the outsider and the client's front gate.

But bodyguards, light or heavy, earn their money sticking their faces *out* when you drive by, not by hiding them, so it looked like Hyde was being watched, and then I thought I knew who it was. A couple of times I had come across him or one of his colleagues when I was on a watching job. When that happened, I called the agency and booked off because it meant that our client had not only hired us but had also complained to the police, or that who-ever I was watching had. Either way, it changed the assumptions we were working on, and we let the client know and dropped the case. No client is worth treading on police toes for. In this case, I half expected that he would whistle up a colleague to follow me, but if he did I never saw one. And that was the last time I saw him until he reappeared to save my life.

~

That night we had dinner with Carole's sister, a psychiatrist who, unlike Carole, thinks she can cook. She and her husband and their ten-year-old daughter live on Oriole Parkway in a duplex full

of expensive new furniture supplied by a famous old store on Yonge Street.

(It's the shop where the assistants are the daughters of the rich and whose minds, while they are "assisting" you, are clearly on the polo or the sailing they are missing. The work is obviously an ordeal, a task they have been set; my own theory is that they are privately educated criminals, caught speeding too often, or smoking dope, or smuggling, and they have been sentenced to community work, and some Gilbertian judge in a spasm of making the punishment fit the crime has sentenced them to spend their Saturdays working in the store where they would normally be the customers. It is the only explanation for the mixture of irritation and contempt with which they greet the customers.)

Although Arlette and Carole have nothing in common, Arlette believes it is important to preserve the ties of blood, as, when she is pressed about it, does Carole. Conversation is stilted because Arlette has very few interests beyond guessing from what people say and do, what they are *really* saying and doing. I give her as little as possible to work with, but she puts my near-surliness into her analysing machine and it comes out as defensiveness. I've suggested to Carole that in her last incarnation, Arlette must have owned one of those boxes for divining sickness in people from a single hair. Since in her eyes I have much to be defensive about, chiefly my failure as an academic and a provider, I am an easy mark.

I enjoy Berky, Arlette's husband, a bit more than I do her. He redeems himself occasionally by a bit of self-mockery, horsing around in a thick Viennese accent—he's a psychiatrist, too—holding printed matter close to his eyes, that sort of thing, which is always a good sign. He also owns his own pool table, for which he has appropriated the best room in the house. I think this is their

marriage bargain. He gets a pool table where he wants it and she gets everything else. Berky and I generally manage a couple of games after dinner before it is time for Carole to get back to her book.

What intrigues me about these two is that both of them make a lot of money advising other people about the meaning of their behaviour, but they don't seem to have profitted much themselves. You would think that they would understand the significance of every behavioural tic, especially the intra-marital ones. It seems to me reasonable that the family life of people should profit from their professional expertise to some degree, that you should expect to eat well at the house of a food writer or properly at the home of a nutritionist, that an accountant would take pride in the house-hold budget. So surely, two psychiatrists, married to each other, ought to realise that she is such a colossal nag and general all-round pain in the ass that he had to buy himself a pool table to block out her noise for the odd hour. Because I've watched him: he doesn't play pool outside the house. I don't think he even likes the game. It's just a shield against Arlette. You would think she would know that, but no doubt it's a case of the cobbler's barefoot children. Nevertheless, he *is* a psychiatrist with the same air of knowing what is in God's mind as the rest of them, and his attitude to me is preferable to Arlette's only in being more tolerant.

Lately, though, ever since Freud has been discovered to be at best an old humbug, and at worst something much worse, I have felt at much less of a disadvantage. Arlette and Berky are both Freudians, and therefore, presumably, left floundering on the beach. I do most of my jeering at home, in the privacy of the bedroom, because Carole won't allow it in public, but I can't entirely resist the odd social thrust, because these buggers have had it so good for so long they've got it coming. From first-year university

onwards, psychology students have been speculating about me, and though now they need better empirical grounds for judging my behaviour, the memory of those eighteen-year-old girls after four weeks of Psychology 101 casually rummaging about in the roots of my neuroses will stay with me for a long time. I try not to be vindictive, mainly for Carole's sake, just occasionally reminding them, as I do my colleagues on the floor above, that literature is where psychology begins and if you can't make sense of a Shakespeare sonnet then you won't have much success with me. I don't rub it in.

Tonight I moved into Homer, led there by the topic of the disappearance of Rosie. Neither of them had read Homer, of course, so I discoursed for an hour before dinner on what truths were to be found in the accounts of Calypso, Circe, and Penelope, three ladies whose stories contain all the experience of the sexual life a man needs to inform him in his middle years (Berky is forty-two), while the brilliantly staged story of Nausicaa, occurring structurally after the Circe and Calypso episodes, but before we meet Penelope, epitomises the response of maturity to the call of a second adolescence. They never got a word in for an hour and I still had a lot left in me, but Carole finally shut me up with a sustained look, and we ate dinner.

Arlette served us chicken gumbo, the right name for it, a lot of legs stuck in a thick, semi-transparent paste with no flavour of any kind. The accompanying vegetables were largely tropical—oddly coloured and bruised-looking. The total effect was of a meal for the homeless in the Caribbean.

On Sunday morning I got in my last tennis game of the year, my personal version of the dying-god ritual. Arlette has suggested that there is something unnatural about my passion for tennis, seeing that I'm just a hacker, that I'm still trying to beat my brother—

who hasn't played for twenty years, for God's sake—or that I am trying to avoid growing old. The truth is that Arlette herself is simply compensating for the fact that she once joined a tennis club and spent a fortune on lessons but in the end was no good at all and had to switch to Tai Chi. She has never had the experience of hitting three good shots in succession and then waiting through the winter to see if, next spring, she could hit four in a row. She doesn't understand.

In the afternoon, after the tennis game, I drove down to Lisgar Street to talk to Helena. I wanted her to make an identification.

"Him," she said immediately, when I showed her the picture in the annual report. Now I was ready for Monday.

~

Richard was waiting for me at the office. He closed the door behind me when I arrived. He was very upset. When I tried to ask what was the matter, he raised his hand, swallowed once or twice, then signalled that we should both sit down.

They've fired him, I thought. They've found a way to get rid of him. My dad is right; they always win.

Not quite. "I've had a student complaint," he said. This was nearly as bad. Nowadays you had to take all student complaints seriously, because nowadays the administration is pledged to. The process available to students, whether the complaint is frivolous, malicious, or justified, can take months to work to a conclusion, and it is a rare administration that will say at any point that the student's case is without merit, mainly because the process has been created without such a possibility in mind.

"What's the complaint?"

"Racism, no less."

Christ. This *was* serious. "What race?"

"Ethiopian."

"What does he or she accuse you of?"

"He. Name of Theodore Kasa. Treating him with contempt, he says. Belittling him. Treating him in an undignified way. I just have it verbally so far. I'm to get a written list later."

"What did you do to him?"

Richard went mad. "See?" he shouted. "You, too. 'No smoke without fire,' you think. 'Must have done something,' you say to yourself. 'I'm not surprised.' 'Likes *Kipling*, did you know?' 'We all had to make excuses for him, sometimes.' Christ!" He bounced around in his chair, as if the seat were spiked, the parrotted phrases pouring out of him.

I wasn't having this. We had been through too much together for him to accuse me of being secretly in league with them all along, like a mole in a Le Carré novel. "Richard," I shouted back, to shut him up. "I mean, what did you do in the sense of 'what act precipitated this'? A student has complained. What preceded the complaint on your part? What? And don't shout."

"Nothing. Nothing. Nothing. Nothing. Nothing. I did nothing of any kind, whatsoever. I gave him a failing grade on an essay once; he appealed and my grade was upheld. But that was months ago. That's not what he's complaining about now."

"What were you teaching recently?"

"*A Farewell to Arms.*"

I mentally fast-forwarded the novel, one I had taught twenty or thirty times myself, but I could find no corner that would create a problem with an Ethiopian. Like every other English department, we have an Index of those works that have caused offence lately, since the discovery that most of the literature we teach puts down everybody except white, middle-class men. Mostly it is a matter of villains. You can't teach a book that associates unpleasant charac- teristics from nose-picking through farting to wife-beating with a

particular race. Rude remarks about western Europeans are still allowed: the snotty French, for example (the French in France, that is, not the Quebec kind); the smug Swedes; the kilt-jiggling, self-horn-blowing, "wee"-saying Scots. In the present case I could have understood a protest against *The Sun Also Rises* for its anti-Semitism, glorification of blood sports, and homophobia, but I could find nothing a male Ethiopian could object to in *A Farewell to Arms*. Female students might complain about the unreality of Catherine, but that, like the androgynous nature of Brett Ashley, is a literary problem, not a slur on women in general. I think.

"What did the student object to?"

"He says I am poisoning the atmosphere."

"What's he going to do?"

"He's done it, I told you. He's submitted a complaint. Now I have to defend myself. To a committee, our chairman has let me know. Against what? Poisoning the atmosphere. Kafka, where are you?" Then Richard went white. "Good Christ. Do you think I could have unconsciously spoken that little music-hall gag in his hearing? You remember? 'What does an Ethiopian say when he leaves?' "

"I remember. 'Abyssinia.' Richard, stop it. There's no way you would unconsciously have told that joke to your class. You told it to me, with the door shut. No one else was here. Don't let paranoia overtake you. You'll be pleading guilty at your own show trial if you keep that up."

"What shall I do?"

Richard was frightened, and with good reason. It was possible that this would turn into the crack in his armour that his enemies had been looking for. He had gathered a lot of enemies over the years as he prowled the corridors like Autolycus, flailing his ten-ured colleagues for their degeneracy. A lot of people, including

most of the administration, would be glad to see him go. It looked
bad, and I started to form a response for him in terms of the best
form of defence.

"Attack," I said.

"Attack?"

"Attack."

"What with?"

And then it came to me, not wholly formed, but nugget-like,
waiting only to be refined. "Accuse them of character assassina-
tion." I scoured my memory for the occasion when I had heard
the phrase used in circumstances like Richard's. I was on the right
track, but I couldn't get the whole memory to the surface. "Never
mind the details yet; stick to a simple declarative statement. Begin
with our chairman. Attack him for agreeing to hear such a foolish
charge. It's his duty to protect you from malice, tell him."

Richard brightened as I spoke. "Let me make notes," he said.
"Now, I begin by attacking our chairman, right. Point is, he is a
gutless wet dream for even listening to this Abyssinian prick,
right?"

"Cover yourself on that. Make the point that the student's
background makes it impossible for him to bridge the gap between
our culture and his, and that's where the problem lies, if any-
where, not with you. It is the administration who enrolled the
student, and as with any other handicapped student, the adminis-
tration must accept the responsibility for giving the student access
to our culture, just as they supply ramps for students in wheel-
chairs."

"Yes," Richard said. "This should give us time to think."

"Also, send a note to the dean saying how apalled you are that
this kind of thing should already be public knowledge even though
you are entirely innocent, that you will hold him and the college

responsible if one misguided student is allowed to besmirch your career."

Here I had accidentally stumbled on Richard's defence, but I did not yet recognise it. " 'Blighting' would be good, too. Work that in somewhere. Then show, on the bottom, that you are sending copies of the letter to the head of our union, and to the chairman, and to all members of the committee, when appointed. Then add that the whole message is strictly confidential and under no circumstances is anyone beyond those addressed to be made aware of the issue."

"Why?"

"I got a letter from a lawyer with that on it once and it frightened the life out of me. I had to pay *my* lawyer two hundred dollars to tell me to ignore it."

I understood his concern, because natural justice has been set on its ear in these witch trials. Normal practice is reversed; it has become the responsibility of an accused instructor to prove himself innocent. But the point I was making to Richard was that in the present atmosphere, all these administration buggers are terrified of getting caught out with the wrong attitudes. And while they are bending over backwards trying to be nice to student minorities, they are very vulnerable to a kick in the goolies from a celebrated victim like Richard.

At this point, though, I was only fishing for words to cheer Richard up, constructing a response out of the vocabulary of the discussions that were going on in every common room, to try to counter the lightness of heart the dean must have felt at the possibility that Costril had blundered and now could be got rid of. But I was slowly realising that Richard did have a case, a real case, that he could make a specific charge against the administration.

"Remember," I said to Richard, keeping the reason to myself

for the moment, "keep it strong, simple, and mysterious. Just accuse them of character assassination, specifics to follow. It wouldn't hurt at this stage if they decided you were bluffing."

"I hope you know what I'm doing."

"I think so. I think so."

Chapter Seven

THE IDEA I'd had about camouflage was fairly simple. In the store room I found a couple of sheets of white cardboard, on which I stencilled the words F. HENRY, GARDENER, along with a telephone number I picked at random from the student directory. After my class I drove north on Bayview with the signs taped to the inside of the back windows of my Toyota van. I circled the area of Steeple Chase Ride, noted the watcher was no longer in place, then parked by the grass verge of the house that was for sale, and walked through the gate to a spot behind the hedge, making myself comfortable on the slope of a culvert that ran

inside the hedge. I sat there all afternoon, taking pictures of everything that moved.

Around four o'clock a Volvo driven by a middle-aged woman disappeared into the drive opposite. A young girl about twelve years old sat beside the woman. Half an hour after that, the woman appeared alone and drove off towards Lawrence Avenue. Just about then I decided I might as well go home, and I returned to the van and sat there for a few minutes, feeling indecisive, when a Mercedes appeared from the drive and turned towards Bayview. The two men inside glanced at me without curiosity as they passed, but a couple of minutes later the Mercedes reappeared and pulled up in front of me. Then I recognised one of the men as the superintendent of the Albany apartment block. The driver and he exchanged a few words, and then the driver climbed out and came over to my van. He was tall and thick, and the hand with which he rapped on my window was about eight inches wide. I rolled the window down and tried to look guileless.

"Can I help you?" he asked, his tone in contrast to his words.

"I'm scouting the neighbourhood, looking for work." I pointed to the signs in the windows behind me.

He reached through my window and opened the van door. "Move over," he said.

"That's okay," I said, or started to say, without any clear idea of what I meant or what I would follow it with.

He crouched down to start getting into the van, then swung his hip at me. "Move the fuck over," he said.

That seemed clear enough. I climbed across the gear-shift between the seats, but before I was completely settled on the passenger side he had started the engine and we followed the Mercedes into the drive of Hyde's house.

"It's the same guy," the superintendent said. "Came to the building sniffing around. Said the cleaning woman had asked him to."

We were sitting around a room more vulgarly decked out than I would have believed possible, although living with the woman least interested in décor in Canada, I've no basis of taste to guide me. The rug was white shag; the five or six armchairs were upholstered in green tweed; there was a sideboard like the Taj Mahal made of blond wood; and there were oil paintings, at least eight of them, round the walls, each with a little light over the top. In the middle of the room was a giant coffee table painted to look like a roulette wheel. There was plenty of other furniture—glass cabinets, at least four clocks, and a pair of crossed oars; it was as if Hyde had bought the lot cheap at a distress sale of an interior decorator, one who deserved to fail. It occurred to me that Hyde might, interior-decorating-wise, be pulling everybody's leg(s), but if that were the case the joke would have to extend to his track suit and his aldermanic haircut. No: Hyde, or someone, thought this was nice.

I said nothing. I was nursing a sore shoulder and had a pain in the chest from having tripped over Mr. Big's foot as I got out of the car, and then having been helped up by his boot.

"Well?" Hyde asked me. He was easily recognisable from the picture in the company history, even in a bright blue track suit which set off perfectly his hair, dyed the colour of brass and teased into a light froth to disguise its sparseness.

I was still trying to assess the situation. If I assumed the building super really was a building super, just picking up a little extra money from Hyde on an if-and-when basis, then my situation, though awkward, was not necessarily fatal. Even Mr. Big had shrunk a little, metaphorically speaking, into something like a

large servant, once we were indoors where he had to be respectful
to his boss.

"I'm still waiting," Hyde said. "We've been watching you
watching us all afternoon." He turned to the big man. "Bring us a
cup of tea, Jackson," he said. "Him, too. Or would you rather
have coffee?" He smiled at me then, I think. His face was corru-
gated, with deep ridges running vertically from his eyes to his chin,
so that you wondered if he ever managed to shave to the bottom
of the valleys. When the lines crowded together he was presum-
ably smiling, or in pain. Noise, or the absence of any, would indi-
cate which.

The super had left the room with Jackson, and now apparently
I was simply paying a social call on Hyde, waiting for the tea to be
brought. But my chest hurt, and Hyde looked happy when I
rubbed it.

Jackson came back with a tray of tea, accompanied by the su-
per, and the two of them unloaded the cups on to a low table be-
tween me and Hyde. There was something slightly silly about
these two putting on a tea ceremony, and I guessed that the super
was simply hanging about, trying to be helpful.

Hyde confirmed this. "No need to wait, Albert," he said. "I'll
come by the building tomorrow."

Albert nodded, gave a little twitch of the hand in a kind of race
memory of a forelock-touching gesture, and left. Jackson stayed.

When the door closed, Hyde said, "So who are you, and why
are you fooking about behind a hedge, watching my front gate?" A
very little of the Belfast accent was still there, enough so that an
uninformed listener might just possibly have guessed wrongly that
Hyde grew up in the Ottawa Valley.

"I'm trying to find work as a gardener," I said. "You need any-
thing done?"

He sucked up some tea. "When I started out with my first catering van," he said, definitely not smiling for the moment, "I'd sometimes have to see me rivals off me pitch. I did it meself; there was no one to help me. The handiest implement was a piece of two-inch dowelling. I've still got some of that dowelling about, so don't be bloody cheeky, matey, or I'll have you digging out me dandelions with your teeth. Now, what is it? What are you hanging about for?"

"I'm looking for Rosie Dawn," I said.

He rearranged the creases in his face to look agreeable again. "And who is Rosie Dawn when she's at home?"

"She's a lady who's gone missing from an apartment in the Albany building, an apartment that you rent." An instinct told me to say as little as possible, but to let that little be true.

"You a friend of Rosie...Dawn's?"

"We have the same cleaning lady. She's the one who is worried. She came to me about it."

"Why is that? You a copper?"

"No. I'm a teacher. But I work sometimes for a detective agency. Surveillance."

"You're not very fooking good at it, matey." He and Jackson smiled at each other.

"The people I watch don't know they're being watched, not like you."

"So you thought you'd try your hand at a little detecting?"

"I thought if I could find out where Rosie Dawn has gone I could calm my cleaning lady down."

"So what brings you to this place?"

"I found out that you own a company called Lunch Box Ltd., which is the tenant of the apartment in the Albany that Miss Dawn used."

"Used? In what way, do you mean used?" There was a threat in his voice.

I thought of a way he might not mind. "Mr. Hyde, am I right in thinking that your company keeps the apartment as a hospitality suite for out-of-town customers?"

Hyde blinked and looked crafty. "Ah, yes," he nodded. "You could be, at that."

"Well, then, whoever in your company makes the arrangements also lines up Miss Dawn when requested."

"I see what you mean. She fooks the clients, like. To help get the business."

"That's it."

"And you figured this out, did you?"

"More or less. What I haven't figured out is whether I'm telling you something you don't already know."

"Is that right? You hear that, Jackson? So, now you know what you know and what you don't know, what are you going to do about it?"

"I don't know. Frankly, Mr. Hyde, what I'd planned was to have a quiet word with you, confirming that I'd guessed right about Rosie Dawn, and get your reassurance that she's just been laid off, as it were." I smiled at the mild *double entendre*, but Hyde didn't. "It would help if you could tell me where to find her, so I could tell Helena, and that would end it."

"You want to talk to Rosie?"

"Not necessarily. *See* her, is all. Maybe take a picture from across the street."

"And if you can't?"

"I don't know. Then maybe I'll have to take Helena to tell her story to the cops."

"Why is that?"

"Rosie's gone missing. Ninety-nine chances out of a hundred, all that means is that she's in the Bahamas, maybe with a client. But one chance says something has happened to her. That's the chance that brought our cleaning lady to me. Now if Rosie has fallen victim to an unsatisfied customer—to coin a phrase—her body might turn up in a vacant lot in two weeks, say. *Then* the cops would unwind her story back to Helena and me and want to know why I didn't come to them yesterday. I could lose my licence."

I do in fact have a provincial licence, but it has about the status and exclusiveness of a fishing licence. I don't even know if I'm supposed to carry it or frame it.

Hyde said, "You couldn't forget what your cleaning woman told you, could you?" He leaned forward and tapped himself on the wallet in his back pocket.

"I'd have to know what I'm letting myself in for." It seemed to me I had more to learn by falling in with Hyde's assumptions about my corruptibility than by protesting my integrity. I wanted at least to know the size of the bribe to find out what sort of game I was playing in.

"And the cleaning woman, what about her?"

"We'd have to satisfy her. Right now she's satisfied that I'm looking for Rosie."

Hyde poured himself some tea, said, "Ah, fook this swill," closed the door, got a bottle of Jameson from a sideboard, waggled it at me, got a nod, and poured two large whiskeys, straight. He ignored Jackson. "I'm not a soak," he said, "but sometimes there's nothing else will do. Cheerio."

After we downed the whiskey (I took the hint that it should be done quickly) he wiped the glasses with a paper napkin and put them and the bottle back in the sideboard. "If my old woman catches me, she'll raise bloody hell," he said. "Now, where were

we? Yes, so you've got a few days before she asks you how you're making out, right? Let's hope it'll be enough. Now. I have an idea, Mr...?"

"Barley. Joe Barley."

"Joe it is, then. I have an idea, Joe. First of all, I'll come clean with you. Rosie Dawn doesn't put out for me customers. We don't go in for that kind of pimping. No, I won't have that. Rosie goes with me, not the apartment. Though we do use the apartment, it's true."

"She's your girl-friend?"

"To hell with that. She's me mistress." There was pride in his voice, the pride of the self-made man. "I don't take her dancing. I just diddle her. See?"

I nodded.

"I pay her well, what she's worth. She comes to the apartment when I call her. I'm being open with you now, understand? None of this hurts anyone, does it? Not unless you tell my wife, say."

I shook my head.

"So here I am, going along, getting a bit on the side, true, but not hurting a soul, then bam, right out of the sky, it's blackmail."

"Blackmail?"

"Blackmail. And kidnapping. They've took Rosie, d'ye see. I received a letter asking me for a lot of money as the price of keeping quiet."

"Who from?"

"That I don't know."

"Keep quiet about what?"

"What I'm telling you. The fact that Rosie's me mistress."

Just his way of telling it made it obvious that he was constructing an edifice out of the pieces of a more truthful structure, and he didn't always have the parts in the right sequence.

"Why did they kidnap her, though?"

"They wanted to make the point strong, d'ye see?"

"Mr. Hyde. How about forgetting who I am and just tell me the story as it happened. From the beginning. Like this: Once upon a time you installed Rosie Dawn, your mistress, in an apartment.... Sorry, once upon a time you used to take your mistress to your company's apartment. Then one day she disappeared. Then what?"

"Then I got a phone call."

"From her?"

"No. From these fellas. Asking for money."

"Did they kidnap her?"

"That's right. As I said, it showed they meant business."

"Let's go back to the blackmail. What's the big deal about you having a mistress?"

"It's embarrassing." He looked at Jackson. "I don't want to be disturbed for a while. I'll let you know when. Not by anyone, you hear?" Jackson left and Hyde poured himself another Jameson, swallowed it, wiped the glass, and came back opposite me. "Jackson's me butler," he said, "but sometimes he's more use outside the door than in."

I guessed that it was typical of Hyde to try and live up to his wealth by buying a bit of status, and calling his bodyguard a butler would be part of it.

Hyde made a vague gesture then, linking me to the sideboard with his finger, the gesture of a cheapskate who ought to have offered me another drink, too, and is now doing so in such a way as to suggest that my saying yes was not to be expected and would give him a lot of trouble, but he was offering. I shook my head, and he nodded and leaned forward. "It's not a thing I want known."

"Who are you worried they'll tell?"

"The wife, of course. Be the end of me, that would."

"Face it," I said. What I was about to say, I'd read in an advice column somewhere. "Tell her yourself. Get the episode off your chest. Then you can start all over again."

"With Rosie?"

"I meant with your wife."

He shook his head. "She'd leave me," he said. "Which wouldn't be so bad, but she'd take our daughter, young Sally, with her. I couldn't stand that." He looked at me from under his eyebrows and shook his head.

"So why kidnap Rosie?" I asked.

"I told you, to show they mean business."

"When will they let her go?"

"When they have the money. But that's another matter. When I have the money, they'll come to pick it up and drop Rosie off."

"But Rosie will be able to identify them."

"Two things there. They won't be in the country by the time we start looking. And they'll still tell the wife if I tell the coppers. By then they'll be counting on me to keep Rosie quiet."

"Do you know anything about them?"

"They're black. Jungle bunnies. Nig-nogs. Spear chuckers."

"How do you know?"

"By their voices. They've got the sound of them."

"So what's your idea? The one you want me involved in?"

"Team up with me. Help me find these bastards. I'll see you're all right." He tapped himself on the wallet side of his bum again.

"You haven't told the police? In blackmail cases they keep your name out of it."

He shook his head. "They'll kill her. They're in deep already, see. Blackmailing is serious, and kidnapping could get them four-

teen years, even if they don't hurt Rosie. They might decide she's too big a risk. No, I'll put the money together if I have to—I've asked them for ten days—but I'm going to try to find out where they might be first. So now you know. Will you come in on it with me?"

"Have you got a place to start?"

"Jackson, me butler, he's got connections. He drove a cab once and got to know a few people. He's going to try to see what a few fifty-dollar bills might bring in by way of information. Someone might have seen something. Two black guys dragging a blonde along? There's got to be a trace on the radar. If we get a sighting in a particular district, then Jackson will see if he can pick up the scent."

I nearly laughed. Jackson, the butler. But context is all: I had assumed that Jackson was pure goon, and so calling him a butler was some kind of joke, but in fact, although Jackson was big, and hard, I was now aware of something about him that made him able to pass for a butler, an actual *lack* of goonishness, an ability to carry a tray without rattling, perhaps.

"And if you do find them, what then?" I asked.

Hyde sat up. "I'll teach the sons-of-bitches not to mess with me. Jackson says he's got a couple of pals who'll do it."

"Kill them?"

"No, no. Nobody's on for that. A bit of knee-capping, though. Jackson could arrange that."

A perfect Jeeves, then. "First you have to find them," I said.

"That's right. You have any ideas yet?"

"The only idea I've had was to watch this house to see if she came out of here."

"Any advance on that yet?"

"How did you meet her in the first place?"

"I was in a bar in Richmond Hill. Nice respectable suburb, I thought, but there was Rosie, dancing on the table in front of me. So I asked her for her card, you might say, and if she made house calls. That was the start of it."

"What's her real name?"

"How do you mean?"

"Mr. Hyde, Rosie Dawn is a stage or table-dancing name, and it sounds like a joke, too."

"That's the only name she ever told me. I see what you mean. I thought it was a pretty name, meself."

"Do you have a picture of her?"

Now Hyde blushed, I think. The black fissures in his face glowed slightly from the inside, like the low-lying embers of a well-damped fire. "Only the ones I took meself."

"Could I see them?"

"They're just Polaroid jobs."

"They show her face, don't they?"

"Some of them."

"Could I see them?"

He considered for a few more minutes. Then he stood up and walked to the wall, stopped, and looked at me. I thought he was going to ask me to close my eyes, but if he was, he realised the silliness of it and took down a large picture from the wall and brought it back to the chair. He turned it over and opened up the backing. Inside between the picture and the backing were a dozen pictures, portraits, about the size of a sheet of typing paper. He handed them to me, his attitude somewhere between embarrassment and pride.

"What kind of Polaroid takes pictures this big?" I asked.

"I had 'em blown up," he said diffidently.

After looking at the pictures, I thought I would know Rosie if I

saw her in the flesh, but not with her clothes on. In none of the pictures was Rosie's face the centre of interest. I chose three in which the face was clear, although in one of the three she was peering through her legs. All the rest were close-ups, her face out of the picture, of no use in ordinary circumstances.

"Don't go losing them," Hyde said. "They're all I've got." He continued, "So there'll be no need for you to turn over the apartment again."

"What do you mean?"

"What do I mean? If you're going to work for me you'd better know I'm not a fooking idiot. The super works for me. He told me how you were hanging around before and after the apartment was turned over. What were you looking for?"

"Clues."

"Yes, well, there're none there, so leave it alone."

I decided then to go back to the apartment at the first chance and look for whatever it was he didn't want me to find.

Jackson returned. He closed the door carefully behind him and crossed over to bend low with his mouth to Hyde's ear and his back to me. He whispered into Hyde's ear for a couple of minutes, then Hyde said, "Is he in his office now?"

Jackson stood up and nodded, still with his back to me.

"And that's all he said?"

Jackson nodded again.

"I suppose I should be grateful for that much, the stupid git. You'd better get on down there, find out what he wants. And tell him I don't want him calling this house again, ever. He might as well be broadcasting every fookin' thing he's saying. Tell him I'll find a way. In the meantime, tell him not to try to get in touch."

Jackson left, and I stood up. It looked as if Jackson's message had been sufficiently absorbing that I was forgotten. When Hyde

focussed on me again, he said, "Right you are, then," as if giving himself time to remember who I was. Then he waved me away.

The ease with which he had apparently lost interest in me seemed to me to fit the impression I had that Hyde had been lying to me, making up a plot to keep me happpy. The only line he had spoken with conviction was at the end, telling me to stay away from the apartment.

~

I drove off, taking a slightly long way round to see if the watcher was back, but the roads were empty. It took me five minutes to get pointed towards downtown, so I was surprised to catch up with Jackson south of Eglinton. I saw him first, his car parked against the curb, and him in a phone booth, not looking my way. I pulled over outside a lamp repair shop to have a think. Point one: Jackson did not want anyone to overhear who he was calling, so the house *was* bugged. Jackson was probably warning whoever he was going to see that he was on his way and to wait for him. (The alternative did not occur to me until much later). Point two: I was now in position to find out who this person was.

I sat there until the Mercedes passed me, waited until he had gone a block, then went after him. As I said before, "following" is mostly done by full-time people in the agency; I hadn't had much practice. I was concerned that if he carried on down Bayview I would have to give him up, because there was not enough southgoing traffic at that time of day to cover me. Then Jackson turned on to Davisville and I followed, across to Mount Pleasant, then south. We had plenty of company all the way to Bloor Street, and he stayed in the outside lane so he wasn't difficult to keep track of. He turned at Queen, and three blocks later I managed to avoid banging into him as he turned quickly into the underground parking lot under City Hall. I carried on and crammed the van into an

illegal space on Elizabeth, three blocks west, and jumped into a cab to get me back to the steps of City Hall. I ran over to the library by the main door, sure that Jackson could not have emerged from the lot so quickly, and got my reward when he appeared out of the rabbit hole on the other side of the skating rink and walked across the square towards me.

Inside, Jackson spoke to the information guy who pointed to a bank of elevators, and he disappeared. It was the cab that gave me the next idea. I waited one minute, then ran over to the information officer waving my wallet.

"That guy who just came in," I panted. "Where'd he go?"

He looked at me and said, "What guy?" to give himself time to get used to me.

"The big guy. In the grey suit. Who just spoke to you. Where'd he go?" I waved the wallet again.

"What do you mean, where'd he go?" He was nominally in charge of security in the space around the desk, and something was telling him I had no right to the information, but he couldn't think why.

"He was in my cab," I said. "He left his wallet behind."

He put his hand out. "I'll give it to him."

"I want to see him count it. No offence. He knows what cab he took. I gave him a receipt. Maybe there's a reward."

The poor guy was in misery, unable to choose between me and his duty, but another attendant who had been monitoring the conversation said, "What are you going to do, Dermot? Make the cabbie wait downstairs? He might be hours."

"Councillor Goodfellow," Dermot said, giving up.

I ran to the elevator, rode up to the twelfth floor to the councillors' offices, ran around to the other side of the building, took another elevator down, and then ran the three blocks to my van.

I got there just ahead of the tow-truck. I felt very pleased with myself.

Councillor Goodfellow and Mr. Hyde were obviously classically connected, whether you got your information from crime novels or the front page of the *Globe and Mail*. It could have been legitimate, of course, if you could forget about the stuff I had heard in Hyde's house. That made it perfectly clear that Hyde and Goodfellow were hand-in-glove over a matter that Hyde was sure the police (or somebody) had bugged his phone to get the details of. Banal, really, one of the clichés of crime fiction; I had to be interested just in case it had to do with Rosie Dawn, but it was probably just your standard crooked-councillor stuff.

The odd element was Hyde's insistence that he hadn't involved the police. Didn't he know about the grey-haired guy in the grey suit and the grey Plymouth around the block? Possibly not, because the cop had taken a bit more care than I had not to be seen, and he may have only been around for a few minutes. And now I had made the connection between Hyde and a crooked councillor, it seemed most likely that the cop was simply monitoring Hyde's connections with City Hall. And again, maybe Hyde knew all about him. Maybe Hyde had been threatened in some way and had asked for police protection. The possibility, though implausible, allowed me to carry on with the case, which I wanted to do. Otherwise, as I've said, when you find the cops watching the same person as you, the instructions are clear: Fuck off, quick.

~

In the meantime, if I were going to look for Rosie Dawn, or even pretend to on Hyde's behalf, I needed a better, more presentable image of her than Hyde had given me. At home, I borrowed a pair of Carole's nail scissors and cut around Rosie's head in the three pictures. These heads I pasted on to blank postcards, leaving

room for the body, and went to work to create composite pictures. Carole gets her share of those mail order catalogues pitched at women who go outdoors a lot, and I used some pictures from these. Although the heads were too large for the bodies, the results were more or less what I wanted. I was ready to start my field research.

First I drove down to Lisgar Street to get Helena to confirm that the pictures were of Rosie Dawn—I didn't trust Hyde even about that, simply because he seemed untrustworthy. He'd been lying steadily all through our talk, and he seemed capable of having a sideboard full of pornography. But she confirmed that they were genuine images of her employer, and I left her and drove the tedious miles up Yonge Street to Richmond Hill.

Chapter Eight

THE IRON Ore House in Richmond Hill features women who dance on the bar, women who dance on your table, and "lap dancers," a category new to me (I've been out of circulation, as far as Iron Ore Houses are concerned, for a few years) but I didn't need a demonstration to figure out what they offered. I sat at the dark, unfrequented end of the bar where a few seats were available for patrons who were just thirsty, and waited for a quiet moment to speak to the bartender. "Her name is Rosie Dawn," I said. "She used to work here. I'm trying to find her."

He disappeared behind a curtain and stayed away long enough

for me to guess I was being looked at from somewhere back there. When he returned he lifted a counter flap and I passed behind the curtain to a back room that looked like the office of a muffler repair shop. A huge two-sided partners' desk was the only real piece of furniture. Apart from that, half a dozen dilapidated armchairs, including one with those chromium arms from the fifties, were scattered about. When I walked in, one of the men at the desk glanced up and said a word to his partner across the desk. This one looked at me, looked at the work on his desk, threw his hands in the air, and left. His boss, as I figured him to be, said, "You're looking for Rosie, I hear. Whaffor? Whassup? All is forgiven?" He laughed. He had the look of a scrap metal dealer dressed for a wedding.

The natural place to sit was in the chair across from him, but there was a lot of paper on the desk, none of it my business. The boss confirmed I was right not to sit there by swinging around in his chair and gesturing for me to move away from the other side of the desk, to come around to face him on his side.

"Are you the boss here?" I asked, when I had moved into neutral territory.

"Yeah. So?"

"You know where I can find Rosie Dawn?"

"Whaffor? Who are you?"

"I'm a private detective," I said. "I've been hired to find her." He said, "Whaffor?" again, then, "Who by?"

I said, "My client wants to remain anonymous."

"Fuck him, then." He paused for a long time, enjoying his control of the conversation. Then, "Guy in the catering business?"

Identification enough, yet still anonymous. "Yes."

He nodded. "He said you might be by."

"When?"

"This aft."

"He was here?"

"We're in touch." Suddenly he got the tongues. "This catering guy's been looking for Rosie for two weeks. Asked me to keep my eyes open, for her or anyone she knows. But no one's seen her, not the girls, not the bartenders. She's gone."

Thus far, then, Hyde was telling the truth, but I was still wondering what he was up to. Maybe he only realised after I left that my first obvious step would be to the place where Rosie used to work, and he had already covered it. Maybe he then tried to call me to let me know not to bother with the Iron Ore House. And maybe he didn't mind my wasting my time.

"Did he tell you to let him know if I came by?" I asked.

"Told me to let him know if *anyone* came by."

"Has anyone else been?"

"No. Just you and the catering guy." He snickered. "Your boss."

"I take it that Rosie hasn't been around and no one's seen her."

"You take it right."

"Do you know where she lives?"

"She doesn't live there any more."

"Where?"

"At the address we have for her. One of the girls tried to make a contact. A personal contact. But Rosie had moved."

"What's her name?"

He looked at me for several seconds. "Come again?"

"Her name."

"Rosie Dawn's name?"

"No one was ever christened Rosie Dawn. That's her table-dancing name. You had to have another one for the records."

But he wasn't listening. "You don't know Rosie's name?" he mused. "Not you nor the catering guy."

"The catering guy's name is Hyde. What was Rosie's?"

"*He* didn't know?"

"No."

"Jesus, what a dink. You, neither?"

"No, but you do."

Now he broke down. He was only amusing himself. "Matter of fact, I don't," he said. "I knew goddamn well that Rosie Dawn wasn't her real name, of course, but if that was how she wanted to be known, that was okay, too. For all I cared she could have been the Governor-General's daughter."

"You think anyone else around here knows? Did she have any pals here?"

"No one got real close to her. I asked the others. They don't know anything about her."

"If she turns up, would you let me know?"

"I'll tell the catering guy. He can tell you." He made a gesture with thumb and finger, rubbing them together. "I *could* tell you first, if you want."

"Tell him. I can wait. I don't have any money that would interest you. I'm a working man. My regular rate is twenty bucks an hour."

He laughed. "I pay the guy who cleans the toilets more than that. How's Billy Jackson making out, by the way?"

"Jackson?"

"The butler. He used to work here until the catering guy offered him a job."

"As a bouncer?"

Once more I had offended with too much accuracy. "We don't have bouncers," he said. "Billy helped to regulate the inflow on Fridays and Saturdays, is all. Besides, he makes his money by being big. He's a pussycat, to tell the truth."

"I think Hyde is happy with him."

He nodded."We were, too. He brought a little class to the job."

I went back out to the bar for a night-cap. I considered re-searching a bit of lap dancing but I couldn't find a price list any-where and I was afraid I didn't have enough money. There was a sign above the bar announcing that they accepted Visa, but I have a strict rule about not using my card except for emergencies. Be-sides, I didn't want to find one of my students in my lap. So I went home.

∽

Carole was in a very odd mood when I got home. First, she wasn't reading, not when I arrived, and not later, in bed. When I came home she was sitting in an armchair under the window, watching me from across the room. I kissed her but got no response—she seemed to be neither in favour of kissing nor against it; rather she seemed to be examining the kiss, internalising it so as to think about it, like someone from another culture trying to understand our customs.

She didn't ask me where I had been, which was normal for her. She is incurious about my outside activities because if I reply in detail it interferes with her reading. But now she was without a book; she simply watched me as if she were uncertain how I might behave. I asked her if she'd had a good day, and what she had for supper, and whether her current book was good. To all of this she replied with some hesitation, each question seeming to drag her out of what used to be called a brown study, a *rêverie som-bre*, as she might translate it. I wondered, but not for long, what was the cause of her mood; not for long because when in the past I had assumed that any moods were produced by me or our rela-tionship, I was usually wrong, and the truth when I got it, pursued by the need to find out where I might be at fault, was invariably

that she had been reading again about the death of Little Nell, or she was struck once more by the realisation of what shits all men were, a discovery occasioned by the conjunction of something that had happened to a friend combined with a rereading of *Wide Sargasso Sea*.

So I left her alone. If it were personal, she would tell me eventually, and if it were cosmic I did not want to find myself in the category of "All men" as in sentences beginning "All men are…" Usually, if she is in a cosmic mood we would make love eventually to show that it was nothing personal. But tonight I needed my sleep.

～

When I woke up the next morning she was still looking at me, which I now found creepy. If I drool in my sleep, I like to think that my love looks the other way, not lies there watching.

"What's up?" I asked. "Why are you watching me?"

She shook her head and slid away without replying, into the bathroom. I followed her out of bed to use the time before I could shower in getting my clothes together.

In the study, I opened my underwear drawer and experienced immediately the frisson enjoyed by the heroes of thrillers when they see that the carefully placed strand of hair has been disturbed —the Papa-Bear reaction: someone had been going through my drawers. The evidence was irrefutable. Three days before, when Carole had last done a load of laundry, I had restacked my clean Jockey shorts in the drawer, flat with the crotch pointing to the back. I had long ago formed the habit of placing them like this, because I had found it the most economical use of space. On either side of the extended crotch I tuck socks, folded flat, not rolled. At one time I stored handkerchiefs in the crotch cavities, but now that I use handkerchiefs only on holidays in Europe, I use the

shorts more quickly than the handkerchiefs, which leaves two
unstable stacks of handkerchiefs that, if they don't fall over and re-
quire restacking, still present an awkward gap in which to file the
crotch end of my clean shorts.

Now I saw immediately that the crotches of my shorts were
pointed outwards, towards the room. My suspicions were con-
firmed when I looked in the athletic-wear drawer where my old
jock-strap, unused since 1986 but retained in case some researcher
discovers that the newish habit of not wearing jock-straps has re-
sulted in a rash of a whole new kind of injury, puckering of the
scrotum or some such, and we'll all climb back into them—my
jock-strap, as I say, for fourteen years firmly anchored at the bot-
tom of the drawer, had found its way to the top of the comic T-
shirt pile. Not only that, but one of the pairs of tennis socks was
lying at right-angles to the others. You don't have to be a neatness
freak to find that weird.

It was the same wherever I looked. The bottom drawer of the
bureau contained all those items I hardly ever use: my long under-
wear for cross-country ski-ing, my track suit used once a year as
pyjamas on the early spring fishing trip, my spare swim trunks, my
MA hood, my red suspenders. All these things had lain undis-
turbed for about two months, but now had clearly been lifted out
and put back too neatly. There is a mild but distinct pee-stain on
the crotch of the long underwear, an oddity because I am neither
incontinent nor careless; odd, too, because it never washes out, but
after being soaked in bleach, stain-remover, and every other eraser,
returns like the bloodstains in Bluebeard's room to attest forever to
the vileness of my body. I don't want to throw the long johns away,
though, because I'm cheap and I only use them for cross-country
ski-ing, an activity for which I change in secret, at home; but out
of deference to Carole I fold the stain out of sight. That is, I did.

Now it was in full view. Someone had been going through my drawers.

My desk was too much of a mess to yield any evidence, but I didn't need any more confirmation. Who? The only possibility was Carole, unless we had entertained some guest who had graduated from exploring our bathroom cabinet to having a general poke round. I waited for Carole to tell me that she had been tidying my room, or some such, incredible and unprecedented as that would be. She said nothing, however, and I was forced to contemplate the very creepy possibility that we had been violated, and the violator had tried, clumsily, to cover his tracks. The idea distracted me enough so that later, when I emerged from the bathroom and she called me to the bedroom, I couldn't think what she wanted at first. It had been some time since she had called me to bed under such circumstances. But when I went in to see, she rolled back the duvet, and I climbed in.

What followed was very agreeable, but I felt slightly as if I were being serviced by a sexual technician, one with an advanced diploma. Afterwards, she said, "Do you think about sex much? When you are alone?"

Obviously the question was connected with our present lovemaking. I said, "I don't know what's going on but something is on your mind. Have I been talking in my sleep?"

Two days earlier we had been watching, in bed, an old Doris Day film in which Doris received phone calls so obscene they nearly paralysed her, and I had been wondering, just before I went to sleep, what sort of obscenity it would take to paralyse someone like Carole today, failing to think of anything that she would not have heard, or read, without turning into stone. Carole has had her share of dirty encounters in the form of flashers and phone calls, and she, herself, is not above shouting the odd bracing word or two

in moments of release. I couldn't think of anything verbal that wouldn't slide off her waterproof back. Nevertheless I wondered now if I hadn't been rehearsing obscene phone calls in my sleep.

She said, "I just wondered if doing it, that is, having just done it, made you think more about it or less, when you're alone."

"Less, I think. Yes, less."

"Do we do it enough?" She was dead serious.

"Sex isn't a quantum thing, like food or exercise," I said. "Is it? I mean, what's enough?"

"All you want?"

"All you can eat, like?"

"Don't make jokes."

"What's this called, what we're having? 'Talking frankly to your lover'? I didn't know you were reading self-help books."

"I just thought you might be feeling...deprived."

"I don't yearn silently, if that's what you mean. Maybe sometimes. A bit. Not much."

"You only have to ask."

And that was that. Mysterious? I should say so.

Before I left, I said, "I don't want to alarm you but someone broke in here yesterday." I had given up the idea that some stranger had been rummaging in my drawers, and therefore the rummager must be Carole, but I was shy of coming right out with it until she had had every opportunity to remember and tell me it was she, and why.

She took it calmly. "How do you know?"

I told her.

"I wonder what they were looking for. Do you have any secrets?"

An odd choice of noun, I thought. "None worth stealing," I said.

"I expect you're imagining things," she said. "Having your menopause early."

"Do you know the signs?" I asked.

"I'll ask Arlette."

I said, "We *are* joking, aren't we?"

"I'll ask Arlette about that, too."

I left, vaguely disturbed, but I had a lecture to give on the meaning of the last book of the *Odyssey*, a new theory I wanted to try out about why Odysseus travels inland until he finds a race of people who do not know what an oar is, and Richard to deal with, and Rosie to look for—plenty to drive intruders out of my mind.

～

I had thought of a way to find Rosie's address, and before I started work I called Helena at home. I was lucky to find her there—she normally left by seven-thirty, but on two mornings a week she went later to English classes, and this was one of those days. I asked her if Rosie owned a car and parked it at the Albany when she was at home to Hyde. She did and she did, but Helena didn't know enough about cars to identify the make, and she certainly didn't know the licence number. But what she did know, that it was small, green, and parked in space number 45, gave me another thread to pull.

～

Before I went into the office I walked up a floor to call on Professor Barry Tucker in the political science department. Tucker yielded up his academic virginity recently when he ran for city councillor. He lost, but he showed by his act that he was more interested in the practice than in the theory of government, that more than the Attic life of pure reason he had developed a desire to get down in the gutter with the movers and shakers. After the election he managed to get taken on by a local radio station as

their urban-affairs pundit, and he writes the odd think piece on
municipal politics for the local papers. What he's really after is his
own television show, but I think he's missed his chance, because
old WASP faces are not where it's at today, or *Today*. So Barry sits
and yearns, wondering whether to run for mayor next time, hav-
ing analysed the results of the election in his ward and projected
them, in his favour, across the city. He does his teaching with his
left hand while he dreams of office, and he's usually free to gossip,
so I started right in with the Case of the Crooked Councillor—the
latest, real one, now in jail.

"How did the developers know who to bribe?" I asked, affect-
ing to know even less than I had read in the paper, so as to give
him lots of room to instruct me.

Tucker leaned back, his arms spread wide, holding on to a
bookcase on one side and a floor lamp on the other. He looked
from side to side as he spoke. For him everybody was an audience;
every conversation took place on camera. A pipe would have
helped, but even Tucker knows those days are gone. He made me
a speech, off-the-cuff, polished, full of witty asides, a speech de-
signed by an old academic who has been asked by a pig-ignorant
student to tell him how the world works. His style is deeply anach-
ronistic and the effect more insulting than impressive. But the
small but sufficient core of real information included the fact that
the membership of the various committees of the Council was
public information, and that Barry Tucker had all the lists of all
the committees. He opened a drawer and pulled out several sheets
of paper.

"Can I make a copy?" I asked

"Now, why on earth would you be interested in knowing about
the membership of committees at City Hall? Would you be wear-
ing your other hat, by chance?"

My part-time job is well-known around the college. "I've been asked to join the executive committee of the ratepayers' association," I said. "I may have to lobby."

He looked interested enough to stop worrying about the camera angle. I guessed he saw the possibility of a little story for him. I added, "I'd like to come back to you if any other questions crop up. May I?"

"By all means. Stay in touch. Let me know how it comes out."

I looked at my watch and wigwagged my wrist at him. It was time for both of us to be getting on with what he was paid so much more for than I.

I taught, and returned to my office to deal with my office-mate's problems.

Chapter Nine

RICHARD had now been served with the written version of the complaints against him. They were three:

One: Richard's attitude towards Ethiopian students was exclusionary and discriminatory.

Two: The classroom atmosphere was therefore poisoned.

Three: The complainant could therefore not perform according to his innate abilities.

Attached to the main points was a list of twenty-three examples in support of number one.

I said, "You can defend yourself against all this, of course?"

"Certainly."

"And the grade you gave Kasa on that old essay—I have to ask—had nothing to do with his being Ethiopian?"

"I'm ready for that one. Two years ago an Ethiopian student came top in my course."

"Good, good. You could have been over-compensating for your deep dislike of Ethiopians, of course, but nowadays they are much more wary of using that jargon, so it will probably be a safe plus for you. And that complaint had already gone to the chairman and the dean?"

"Yes, and they both rejected it."

I thought for a moment. "Years ago, when you and I were students, you could sometimes change courses by pleading a personality conflict with the instructor. You remember?"

"Yes, that happened to me once. Silly bugger of an instructor completely misconstrued Eliot's 'Preludes' because he'd never heard of the Aerated Bread Company. He thought ABCs referred to spelling primers, not teashops. I corrected him, foolishly, because his hostility to me thereafter meant I was doomed, until I got out of his way by pleading a personality conflict. I switched to Middle English, *Piers Plowman* and all that shit."

"You don't think there might be a personality conflict here?"

"Of course there might. I detest the bastard. But not because he's black. He's been a nuisance from the first day. I don't doubt that something I did or said put him off from the beginning, but not my being white. I probably remind him of his father."

"Who supports him?"

"The Student Union, for one."

I had cleared the ground, and now I told him what we were going to do. "You need a lawyer," I said.

"On my salary? Don't be silly."

"I know one. A woman. Black. She'll do it for nothing. Want me to ask her?"

"Is this necessary?"

"I told you already. Attack! Refuse to defend yourself at this time, and serve notice that you intend to sue the student, the Student Union, all the members of the appeal committee, and the college."

"Sue them—for what?"

"I told you, character assassination."

Richard said, "Who is this lawyer? Why should she defend me for nothing?"

"Not defend you. Attack them. And she won't be doing it for nothing. She'll be paying off an old debt to me."

"When did you ever make a black, female lawyer grateful to you? And how?"

"Ten years ago she was a student of mine, and that's all you need to know. I get a Christmas card every year with the inscription: 'Still in your debt.' This will help to pay off the debt and if I get a card next year I'll know that she loves me for myself alone."

Richard tapped a pencil against his teeth. "If it doesn't work, I could be screwed."

I disagreed. "In this new game, no complainant suffers any penalty for the equivalent of malice. If they lose they go home and wait for another chance. The only way for you to stop them attacking you is to attack them. It's like taking out a court injunction against being picketed. Think of it: you could be a precedent, a seminal case."

"I could, couldn't I? I could be crucified, too, though. No? Right. Bring on the Queen of Sheba. Let's have at them."

I reminded him that the Queen of Sheba was herself Abyssinian, and that he should watch his tongue.

But he was much too cheered up to be put down. "And if this lawyer of yours is, what could be better?"

~

I drove down to the Albany, parked behind the building, and walked down the ramp to the parking lot underneath. I was in luck. A ministering attendant sat in a fairly large booth by the exit. On one side of him was an automatic gate for the tenants; on the other, a window through which he took money from the casual parkers. It costs a fortune to park downtown, and this building, like others in the area, picks up some useful change renting some of its surplus space to outsiders.

I smiled at the attendant and moved my shoulders about ingratiatingly. A while ago, I told him, my wife had backed into a car parked in the garage. She had panicked and driven off, hoping no one had noticed, but the owner of the car would have noticed that its right rear light was smashed. I'd been out of town, I said, and I had only just heard what she'd done, and I was afraid she might have got herself into big trouble. I had come to leave a note on the damaged car, but it wasn't there. Could he help me?

It was a small green car, parked in space number 45.

"Sure," he said. "I'll put it on for you when she parks there again. She's been away herself, though. Maybe she didn't notice it. Maybe you'll get away with it."

"It's too big a risk," I said. "My wife's already got nine points. I'm going to report it to the cops and say I did it."

"When did this happen?"

"A couple of weeks ago."

"So what are you going to tell the cops?"

"The truth. Only I'll tell them I did it."

"So they'll ask why didn't you tell them right away?" Now he

was getting really interested, wanting to help me get the story straight.

After a minute, I offered, "Maybe I should say I left a note on the car with my name and address, but I never heard?"

"So. You did what you could." He nodded judicially.

"Some mean bastard could have taken the note off, just for kicks. That's the kind of story anyone could make up."

"Like you're doing now?" He nodded. "So you're worried, like. Maybe *I* saw the crash, and then a couple weeks later, wondering why nothing has happened, I turn you in, right?"

"Right."

"So why are you telling me? Got it. All this bullshit charm you're turning on me now is just to find out if I did see it. Right?"

"You're a hard man to fool."

He looked happy.

I said, "My wife couldn't remember the kind of car, let alone the licence plate. But if *I* got to the cops, they'll expect me to know that, won't they?"

"I would think so," he said, and waited.

"So I wondered if you knew that, the kind of car and licence number." I paused, wondering how to convey subtly that a little money might change hands if he came up with the information. This is something I'm not good at. Everybody else seems to know precisely who to bribe and how much, but when I try it I usually wind up insulting the guy by offering too little, or by offering a bribe at all. Now, though, sensing my dilemma, the attendant eased me off the hook. "What's it worth to you?" he asked.

I took out a ten, and he looked away, waiting. I changed the ten for a twenty and he leaned out the window and twitched it from me. "Green Honda Civic," he said, reading from a list. "Licence number 040 koo. The owner's name is Rosie Dawn."

I wrote it down in my address book and thanked him.

"By the way," he said, "how come I didn't see or hear this crash? That space is ten feet away."

"It was in the evening."

"Then the other attendant would have reported it. He's very honest." He laughed again. "I know what you're up to, buddy. There never was a crash, right? You're after Rosie's ass. Let me know how you make out. She charges a lot. I asked." He withdrew and pulled the glass across, making a gesture that is obscene in Greece.

I pretended to recover in time to adopt an expression of lecherous complicity. He was a cute one, all right.

∽

The constable on duty took down the information and put it into his computer. "You say someone ran into your wife's car two weeks ago when it was parked on Bloor Street?"

"That's right. Hit and run."

"And someone else left a note on your car, with the licence number of this bozo?"

"That's right."

"So why didn't you report it?"

"I didn't know about it. I was out of town. See, my wife was illegally parked, and she and I fight a lot about the way she handles that car, so she was afraid to tell me. But I found the bill from the body shop in the glove compartment, and then I heard the whole story."

"When?"

"Last night."

He stroked his computer for a few moments. "Two weeks ago? You have the exact date?"

"It's on the bill. I didn't bring it with me."

"Anyway, for the last three weeks that car has been in the pound. Still there. It was towed away from an overdue meter on Charles Street."

Shit. "I don't under*stand.*"

"Nor do I."

I thought quickly. "Do those guys in the pound go joy-riding in the cars they keep there?"

"Very unlikely. They'd be finished if anyone caught them. Try something else."

I had had time to think. "I've got it. Somebody whose car was impounded tried to set up the guys in the pound in revenge for the three hundred dollars or whatever those mothers charge for stealing your car. See, he made note of a licence plate he saw in the pound, and wrote a note saying it had crashed into another car *while it was supposed to be in the pound!*"

He looked at me. "I'll tell the duty sergeant. In the meantime, let's get *your* story straight. Okay?"

There was nothing to do except go through with it. I still hadn't got what I wanted. I gave him all the information he needed, then said, casually, "Who owns the Honda?"

"Huh?"

"The Honda. Who owns the sucker? How come they haven't gotten it out?"

He said, "Maybe his wife is afraid to confess she lost it. Pretending she lent it to someone."

I laughed like a man who could take a joke, wondering how I could put the question again without sounding obsessed.

"It's a mystery," I offered, racking my brains.

"That it is. Maybe it'll be a headline yet." He looked at his screen. "Kettering. So if you hear of a body, name of Lynn Kettering, fished out of Lake Ontario in the next little while, you can

tell your pals you got there first." Then he was bored with me, turning away to play with some papers on a back table. But I had what I wanted.

Chapter Ten

I KNEW now who I was looking for and just maybe where to find her, or rather, where to begin looking. I had known where for some time, of course. The accident of my teaching the *Odyssey* when Helena's Rosie Dawn went missing was not such an astonishing coincidence as might appear at first, not at all the kind of thing that novelists engineer to fulfill their self-allotted task. In the first place, even if I had not been teaching Homer, the name Rosie Dawn would have struck a chord. Even if I had never *read* the *Odyssey*, I would have come across the phrase more than once in the course of studying English literature for seven years. It was easy to make

the connection that Rosie Dawn was probably a student, table-dancing on the side, as it were. So it was that I guessed that Lynn Kettering was, or had been recently, a student of the *Odyssey*.

~

Counting the universities, the satellite colleges, the community colleges, and the extension courses, there are in Toronto about thirty separate jurisdictions whose classics or English departments might be administering a curriculum containing the *Odyssey*. Then there are the high schools, especially the superior private schools. I made a decision to leave out the high schools for the moment and sat down to phone all the colleges. It took me a good part of the afternoon, but I found seven courses that offered the *Odyssey*, and I started to telephone the instructors of these courses. It didn't surprise me that not one of the people teaching the poem was in his or her office when I called: most of these birds are represented by little notes on their doors, and equally tiny messages on their answering machines, telling students during which two hours a week they might be sighted, but I had composed a message for their machines that I thought would probably bring a response, the gist of which was that it was a matter of life and death, possibly.

They all called me by dinner-time. To the first two, I explained that I was a social worker trying to find a student of theirs, Lynn Kettering, on urgent family business. I did not wish to go into details until I had spoken to Miss Kettering, I said. The first one said he had no such student, and I suggested she might be using another name, and had anyone dropped out lately? He said, "No," and hung up. I went through the same routine with the second caller; then the third one, from the technical university downtown, said he had a student of that name (he did that poncey professorial bit: "I have a student of that name," scrupulously careful in case the town had suddenly started breeding dozens of Lynn

Ketterings studying the *Odyssey*, and his was not the one I was look-
ing for) but she had not appeared for two weeks, maybe more. He
couldn't be sure. I thanked him and asked him to give her a mes-
sage if she should appear. I also asked him if he would make a
small announcement in class to the effect that if anyone knew how
to get hold of her would they please call me. He said he would do
that, and that his next session with that class was scheduled for the
following day.

~

The caller the next day had the Trinidadian lilt to his voice that I
had been listening for ever since Hyde told me that Rosie's abduc-
tors were black. "You're looking for Lynn Kettering, I hear," the
voice said. Much later I realised how important context, assump-
tions, and preconceptions are when you are trying to place some-
one socially, or perhaps I mean sociologically. Forgetting Hyde's
comment for the moment, I was sure this voice was Welsh, which
is the only nationality whose English dialect, at its best, deserves
the term musical. In fact, after a sentence or two, I was waiting for
the next one to end "whateffer" or some such, but then he
dropped a syllable, or sounded one, that changed his colour from
Welsh to black.

I said, "Are we talking about Rosie Dawn?"

"That sounds familiar," he said, cautiously.

"Where is she?"

"Rosie's safe," he said. "You can have her and the tape when
we have the money. Tell Hyde that."

I said, "I don't have the money. I didn't come from Hyde. And
I don't know anything about any tape. I'm just looking for Rosie
Dawn." Crooked councillors, tapes—Rosie's kidnapping was turn-
ing out to be full of clichés.

"Who are you from, then?" In a phrase like that, the pure

Rhondda Valley seemed to sound through, clear as a chapel sermon.

"No one. A friend of hers. I want to know if she's all right. I'm not interested in anything else."

"You come on down and I'll show you she's all right."

"Where to?"

There followed a bit of Welsh/Trinidadian whispering to someone else. "Here's the address."

It was at the south end of Spadina, on the corner of Adelaide.

"Be on the kerb at midnight," the voice continued. "Bring an interesting personal item with you. Maybe you got a pair of black-and-white striped boxer shorts? Or your favourite T-shirt with a cute saying? Don't wear it: carry it. Okay?"

~

I settled on the hat that I wear to fancy-dress parties, a coonskin job with a tail hanging down from the back. Most people who say they don't like fancy-dress parties mean they are intimidated by having to invent a witty costume, but I solved the problem with my coonskin. I wear it with a dinner jacket I bought cheap years ago when I was invited to two formal occasions in one year and the rentals were getting expensive. I wear a label made from a shirt-laundry card on my back, inscribed THE MAN WHO CAME TO DINNER. No one has ever asked me what the ensemble "means," because they are afraid that the answer, to anyone who has seen the play, is obvious. And who, lately, has seen the play? So my coonskin gets me off the hook. And you can carry a coonskin hat in a bag until you reach the door. Without it, I would probably find myself on Halloween on a street-car wearing antennae topped with Ping-Pong balls and with my face painted silver.

I hadn't reckoned on what it would feel like, though, to be standing on the corner of Spadina and Adelaide holding a coon-

skin hat on a warm October night, but they didn't keep me wait-
ing. At midnight a panel truck pulled into the kerb and the back
door opened. I crouched down to get in, and a pair of hands
slipped a black bag over my head and pulled me inside. I struggled
for a moment, and the owner of the bag let me, demonstrating
how the cord tightened around my neck as I fought, and I gave up.

"That's the idea," said How-black-is-my-valley. "Relax. We're
going for a little ride."

Not relaxing words.

Then he said, "What did you bring? What's this? Christ, it's a
bloody Davy Crockett. Oh, she'll like this."

I had no idea where we were being driven during this ex-
change, but we soon stopped and my companion got out. In a few
moments he was back, and we took off again and began a long
drive, mainly along thoroughfares apparently without traffic sig-
nals, and then stopping and starting every few minutes in familiar
urban fashion. After some ten or fifteen minutes of this, my com-
panion said, "Time enough," and shortly after that we pulled up.
I heard the window roll down and up and we were off again. Ten
minutes later (I guessed), we stopped. He got out and came round
to the back of the truck, opened the door, and drew me out. We
crossed a wide sidewalk and he leaned me against a door. "Count
twenty-five," he said. "Twenty-five. Then take the bag off and look
at this." He put something in my hand, a square of paper, leaned
close, and whispered, "Then fuck off. This is nothing to do with
you. Okay?"

I heard him cross the sidewalk and the sound of the truck driv-
ing away. I grabbed the hood off my head and looked at the pic-
ture in my hand. It was a Polaroid, still damp, a picture of Rosie
Dawn with clothes on, wearing my coonskin hat. She looked very
irritated.

~

I had my other lives, both personal and professional, to deal with the next morning before I could pursue Rosie any further. Besides, the Polaroid trick had worked just as the black Welshman had planned. She was obviously unhurt, so I didn't have a powerful sense of urgency about finding her.

When I woke up, Carole was sitting beside me, more or less cross-legged. She was holding her ankles with her hands to keep the soles of her feet facing each other, and between her feet she held me upright, though my full bladder made this easy to do. She was moving her feet back and forth, grinding me between her soles. An alien, watching, with a limited exposure to our civilisation, confusing Carole with her primitive ancestors, might have assumed that she was trying to create fire. Then one foot slipped, and a ragged-edged big toenail slashed the base of the shaft, just a superficial cut but enough to wake me and ask her what she was doing and to please stop it.

"Don't you like it?"

"It's hard to say. Having my penis twirled between your feet is new to me, especially when I am asleep. I think you should stop now, though. At the moment, I hope that between us we can stanch the blood from this little wound without outside help, but we should take it as a warning. I don't want to have to explain to some disgusted interne why I have a nasty cut on my dick. So, tell me what's going on?"

I was concerned. We were still distant, or she was, but her distance was now alternating with what seemed to me to be a ferocious desire for sexual experimentation unlocated in any passion for me.

"I just wanted to be sure that you aren't yearning for some jolly I don't know about. I wouldn't mind as long as it doesn't hurt. I

read about this in the unexpurgated *Thousand and One Nights*. And I remembered that you said once that you liked my feet."

"What I like about your feet is the absolute opposite of this. You have nice feet, pretty feet; I've never seen feet I like so much, but to *look* at. They are innocent feet, don't you understand?"

"I thought maybe you were suppressing your real feelings about feet."

I sat up. "You want me to be honest?"

She nodded, warily, then moved back slightly, prepared for the worst.

"Then sometimes, I confess, I wish you were more interested in cooking, in bridge, and in a thousand other ways of spending your leisure—other than reading, I mean. But I have no complaints about this department." I thumped the bed. "Okay?"

She regarded me thoughtfully, an improvement over "distantly," but still unbelievingly, and slid off the bed before I could reach out to kiss her.

At breakfast, she went back to watching me.

Chapter Eleven

I HAD FIRST come across Alice Borden ten years before as a student in my first-year course. She was from Trinidad, a very retiring girl dressed in what I thought of as missionary drab (she told me when we were discussing her first essay that she was sponsored by her home church), thickish garments of grey and dark blue. She was black, and very beautiful, and I dreamed one night that I was handing back an essay and the essay caught fire.

During the first term she concentrated hard on her work, submitting neat little compositions in a copperplate hand. Then, after Christmas, her handwriting began to deteriorate and her ideas became more interesting, until at the end of the term she wrote a

pleasantly fiery little attack on James Dickey's *Deliverance*, a genuine piece of criticism, unspoiled by anything I had said. The day I handed it back, with an A and a note of congratulation, she burst into tears. She told me then that she was dropping out of school to return to Trinidad. There was only a month to go in the academic year, but she was broke and could not pay her rent. What upset her most was that she was letting down her church.

I had never before, and I have never since, seen my duty so clearly. She had caught me at exactly the right moment, the equivalent of the time (once a month in my case) when you give a bum all the change in your pocket plus a five-dollar bill to make up for all the times you have dodged his colleagues, or grunted a refusal, simply because, moving towards your forties, you still haven't settled the argument between charity and the feeling that you are being conned by wealthy beggars. So I was vulnerable and what happens next makes a nice story, which I don't mind retelling even though it reflects well on me.

Feeling as though I were playing a deleted scene from *Show Boat*, I persuaded Alice after a lot of argument to accept enough money from me to handle the rent and groceries for the rest of the year. Maybe three hundred dollars. The result, when she finally agreed, was that she worked so hard, for herself, for her church, and now for me, that she won the first-year prize for the best student, a prize of five hundred dollars. She paid me back on the spot and went home in triumph. I never taught her again, but she called in to say hello at the beginning of every term after that. She came back for second year a changing woman. She still wore black schoolgirl shoes with straps across the instep, but elsewhere the missionary drab was retreating, being displaced by a horizontally striped green and yellow sweater and a brown skirt. Her earrings were bigger and brighter, too, and she was wearing lipstick.

By the beginning of the third year the metamorphosis from Trinidad chrysalis to Toronto butterfly was complete. She even laughed differently. A year later she was into silver nail varnish. She had also gotten married and enrolled in law school. The year after that she was divorced, a single mother, but still in law school, and wearing a lot of khaki. As far as I could tell she was coping easily. She asked me to come to her graduation, but I had taken a summer school job in New Brunswick and couldn't get away. I saw her only once more after that, on the subway, not recognising her shining beauty until, with all the passengers watching, she crossed the subway car and hunkered down to intercept my eyes (I was reading) with, "Sir, don't you remember me?" Then she said, "Alice Borden," and laughed at the look on my face, then leaned up and kissed me on the cheek. She told me quickly that she now had her own law practice, and she had not remarried. She said goodbye as we came to her stop, leaving me in a bright glow all the way to Summerhill. I haven't seen her again, but I get a Christmas card every year, reminding me of her debt.

I had called her the day before and she had offered, only half-jokingly, to cancel all her appointments for the morning, now that I finally needed her. We settled for half an hour at ten.

∼

Her office seemed to be decorated almost entirely with framed photographs and diplomas, a pictorial and graphic history of her life, from growing up in Trinidad to what looked like a ribbon-cutting ceremony opening this new office.

"You have a place of honour, Mr. Barley," she said. She stood up to point out one of the pictures, a group portrait of the awarding of her first academic prize in her first year. I was doing the presenting of the cheque.

"Now, sir. What can I do for my favourite teacher?"

I had tried repeatedly to stop her calling me "sir" and "Mr. Barley." "If you're Alice," I said to her after she graduated, "then I'm Joe."

"No way. Not to me. Mr. Barley it is, now and always."

It sounds flattering, but I thought then that for all her admiration for me, she was concerned to keep some distance between us, sensing, as she could not avoid doing, that once the automatic, and in my case still functional, hands-off-the-student ban had lifted itself with her graduation, I might just change my attitude. I thought she understood the reaction she provoked in me, a reaction I was now free to express, without wanting to reciprocate. She had every kind of good feeling for me except that, I thought, and she had no intention of allowing me to damage her esteem for me by having to fight me off. "Mr. Barley, sir," kept me in my corner.

I explained my mission. It took only five minutes to outline Richard's problem and ask her, for a delayed fee, to advise him.

"Is he a racist?" she asked.

I was shocked, but only for a moment. "A closet racist, maybe. No worse."

"I'll take your word. Has he done anything yet?"

I told her about the letters he had written on my advice.

"That's good," she said. "Let me get this straight, now. The student is charging racism, that's a form of harassment, right? And the key to your defence..."

"Attack."

"The burden of your charge, then, is that the administration has maliciously mishandled the student's charges in spite of a clear precedent in recent college history that caused a policy to be formulated."

"That's right."

"Some time ago there was a committee, you say, that brought out a report...."

"Adopted by Academic Council."

"That made it law?"

"After the Board's approval, which it got."

"And this report said?"

"That a clear distinction exists between academic appeals, appeals against poor grades, for instance, and complaints of a moral nature, like charges of harassment, racism, and so on."

"You sure about this?"

"I'll get you a copy of the report. But I'm sure. I was on the committee."

"So this student is charging your friend with racism, which according to your rules should be heard in private. Why? Again."

"Because innocent or guilty, the publicity surrounding such a charge is a form of character assassination."

"And the student isn't just saying the instructor was racist. He wants his *grade* set aside because of this bias."

"But the issue still isn't the academic quality of the paper. That's where they stumbled. Someone misreading the problem has mishandled it. Perhaps wilfully. Many people regard Richard as a nuisance."

"Is he?"

"Oh, I think so."

"But that isn't the issue. No, it sounds good. Let's go get 'em. Tell your boy to phone me, and we'll get together. In the meantime, though, tell him to start putting together the defence in case they get this thing up to a hearing. Get some letters from some former coloured students, I mean former students who are coloured; if the present class is on his side, have them write a group statement of support, denying that they feel harassed."

Alice stood up. "Tell him not to worry. We're on the right track." She came round the desk to shake hands and I stood up and a handshake became a hug. It was all the pleasure I had ever thought it would be to hold Alice tight. Then she broke away.

She walked back around her desk. "That's it, Mr. Barley. It isn't my fault. You were too impeccable in your student relationships. And it isn't a tragedy. Remember teaching us *Tess of the d'Urbervilles*? Now *that* was a tragedy. I thought that book was written for me, because I *yearned* after you. My Angel. But now it's too late. Right? What's that Hardy said about nature never getting the timing right?"

"As you said, you were my student."

"That's right. A little black girl from Trinidad. Not to be touched. And there I was, yearning for you. Never mind, at least I got to tell you, finally." She laughed.

Someone else might get a novel out of the story of me and Alice, a short story, anyway, but there it is in its essence. I was still sorting out my emotions when she added, "But anything I can do for you, like defending your friend, let me know."

Then I thought, Alice is Trinidadian; Rosie's abductors are Trinidadian; Alice may be the only Trinidadian whom I can trust with this story, because she can trust me, and maybe, just perhaps, she will have a helpful response from her world to mine. So I told her the story.

As I finished, I watched for the body language. If she leaned back, she would be dissociating herself from me and what I was asking. If she leaned forward, she was going to try to help.

She put her elbows on the desk and covered her mouth with her fingertips while she thought. Then she hunched forward towards me. "Go to the police," she said.

"Sure, eventually. But I'm going to tell Hyde that I'll give him a

couple of days to find her before I do that. In the meantime, I'd
like to find her myself."

"So you want me to help you find two West Indian kidnappers
who have taken off a table-dancer for ransom. I'll ask around,
shall I? Shouldn't be a problem." Her voice was toneless,
emphasising the incredible nature of the suggestion she was put-
ting in my mouth.

I stood up. "I just thought…"

"Go on…"

I shrugged. "I did hesitate to ask you, Alice." And then I went
for broke. "Christ, for all I know you spend your spare time limbo-
dancing in some booze can in the warehouse district, and you
overheard a couple of guys last night talking about this girl Rosie
they had to keep locked up.…"

For a moment I thought she was going to tip the desk over on
me, and I pushed myself back. Seeing this, she laughed, and
laughed again.

"There's just enough in that to make you ask me, isn't that
right? All right. Yes, I'm a West Indian and I'm part of the com-
munity. I help my black sisters, if you like. But I don't hang out
with the limbo-dancing crowd, as you call it. Does that still go on?
Here? But I do some charity work, defending people for free, and
I know some of the rascals, and some of them know me. I'll ask
around. Oh, don't get into a sweat, I know how to ask without
raising a posse. I'll see if anyone will tell me anything."

"See?" I said. "That's why I asked."

Chapter Twelve

I REPORTED to Richard before my poetry class. He was more used to his situation by now, and what I had to say cheered him up further.

I spent the next hour explaining to my students how a sonnet works, using Shakespeare's "Let me not to the marriage of true minds" to make my points, and then I was ready for Hyde. I had something to report and a need for further orders, but before I could see Hyde again I had a small niggle to resolve.

As I said earlier, I left graduate school before the new deconstructionist philosophy put all in doubt, and I'm glad I did, but

occasionally I pick up a bit of the latest jargon (or jargon new to me), and try to re-render it in the idiom of my day. Thus Hyde, I understood now, was probably what they call an "unreliable narrator"; in old-fashioned terms, a liar.

I also, I must confess, left graduate school before I had to come to terms with the computer and all the associated forms of information retrieval. For me a computer is a mechanical card catalogue to tell you if the library book you want is on the shelves. Fortunately, I have former students who are experts in this area, who can access information, as those who like to verbalise nouns say, and now I called up a man on the foreign desk of the *Globe and Mail*, and within an hour he had faxed me three little articles written for the business section concerning Hyde.

They were all on the same subject, the possibility that Hyde's company was to be taken over by an American company, and that a second American company was interested, and also that Hyde himself was making a takeover bid of one of the companies interested in swallowing him. It all sounded, as these affairs always do, like an account of the sex habits of those insects that fuck and eat each other at the same time. In the meantime the shares of Hyde's company had gone up about fifty per cent in six months.

I understood none of this, but a call to a former student of mine on Bay Street brought a promise to investigate Hyde a little further and call me back. I had enough already, though, to arm me against Hyde when I met him next. He was certainly a liar, and probably a crook, and the police were watching him. I, on the other hand, was to him a part-time college teacher-cum-security guard who would eat any old mulligatawny he was fed, but who, nevertheless, had shown some cunning in the way he had tracked down Hyde in the first place, and therefore ought to be allowed to

run free to see what he could turn up, like a puppy after old bones—a puppy on a leash, that is.

It seemed to me that the advantage was all mine.

~

The next day was Friday and I was free in the morning, so I called Hyde to let him know I would be coming, and that I had some news for him. Then I turned my attention back to Richard's situation.

I was alone in the office when the news came that Alice had been quick off the mark. The department chairman put his head round the door. "Can I see you for a moment, Joe?" he asked. "Now. In my office."

His door was hardly closed behind us when he threw Alice's letter at me. "What the hell is this?"

Alice's letter, as I expected, said that she had been retained by Richard to represent him in an action he wished to pursue against the college, the dean, the chairman, and all members of the appeals committee.

"Not the Student Union?" I asked.

"Don't be funny. I am only asking you because you share an office with the sonofabitch. You know all about it, don't you?"

"I can testify to the extreme distress he's been caused by this so-called appeal."

"I mean this lawyer. I know who she is. You've been telling her story around here since God knows when. You put him up to it, right?"

Fred Berger is a good chairman. Given the mare's nest of anything to do with academic administration these days, only a status-mad fool could want the job. Fred has it because a large majority of the department begged him to do it, and he does it on the same understanding as the cook in the fable about the construction

camp, that anyone who complained would find himself doing the cooking. I said, "I don't know about that. Richard doesn't bark at my bidding. But I did suggest Alice as his lawyer, yes."

"Why, for Christ's sake? What have I ever done to you?"

Even from Fred, this took my breath away. Nice guy that he is, he is part of the system that had made me a second-class citizen.

I said, "You don't really want me to say, do you? You represent the administration that has been exploiting six members of this department for periods of up to ten years, and intends to go on doing it until we reach the age at which you can tell us to fuck off. You've made Turks of us all."

"Turks? What the hell are you talking about?"

"Turks. Turks are people who do all the dirty work but are never allowed to call themselves citizens. Like the German government, you will ship us out as soon as the dirty work dries up, or as soon as there's only enough work for the permanent citizens. We can't vote, we can't hold offices like yours, and the only reason we are here is that you couldn't function without us. And you ask me what you have done to us?"

I felt a little sorry for Fred. As I say, he's the best man you could find of the "I'm-just-obeying-orders" kind. Still, I enjoyed saying it because I'd been rehearsing it for years and I've got the lines down cold. I continued, "But don't worry too much. See?" I pointed to the bottom of the letter. "He's also sueing everybody else, so they'll probably pay up and get you off the hook."

"Pay up? What's there to pay, for God's sake?"

I'd struck a chord. Academics, it's well known, are more interested in saving money than any other professional group in our society. I think the reason is that, unlike doctors and dentists and lawyers, they tend to come from poor backgrounds, with parents who can make no contribution to their education and are not so-

phisticated enough to warn their children against pursuing an academic career. Thus they endure eight to ten years of student poverty and it makes them appreciate money, makes them cheap. Fred was no worse than most, and better than some. I know of one guy, a teacher of Spanish, who asked for a dollar back from the convener of the annual Faculty Association wine-and-cheese party on the grounds that he had only drunk one glass of wine and he understood that the five-dollar ticket allowed for two.

"Damages," I said. "The word will get out. It's possible that Richard's career may be ruined even if he wins. He may feel he can no longer teach here, and no one else will touch him. He'll be *controversial*. And he's not forty yet. It would take a lot of money to look after him to—what?—eighty?"

"Christ Almighty." He hunched himself over his desk, trying to think. "Why isn't he sueing the student, and the Student Union?"

"You're missing the point. See, the student has every right to complain, and the union is bound to support him. You can't sue a student for that. It's the way you people handled it that's actionable."

"We've been impeccable! I denied the appeal, the dean denied it, and the appeals committee denied it. So what's the problem? We jumped through all the right hoops."

"I shouldn't be telling you this."

"For Christ's sake, Joe, tell me."

"You are confusing two kinds of appeal."

He wasn't listening. "Why? How? The kid failed. He appealed his grade. I reread the paper. Two pages of twaddle. The dean agreed. Appeal denied. What was wrong with that?"

I sighed patiently, and sat down. As I said, I felt sorry for Fred. He wasn't a bad guy, but Richard and I and the others have taken a lot of shit from his chair over the last ten years. This was fun. I

went over the fact that Fred was talking about something else altogether, the student's old academic appeal. Fred had jumped to the conclusion that the student was still complaining about the essay grade, but this was a new and different complaint and I explained the difference between an academic appeal and a moral charge, and how each should be handled. I ended, "You've fucked up, I'm afraid, Fred," as kindly as I could.

"So what do we do about it?"

"I haven't the faintest idea." I watched scraps of hope and fear chase each other around and around inside his head. He caught at one of them.

"Is it possible that Richard *was* harassing this student?"

"I'll forget you said that. Anyway, that's not the point. The point is, win, as he most certainly will, or lose, Richard's reputation is irreparably damaged. It's rather interesting legally. If Richard's action is resolved before you deal with this student's charge, then the case is over, I would think. But if you even continue to prepare to hear this student, after being served with Richard's letter…no, I don't think you can, can you? You can't knowingly continue doing something that may be wrong simply because you started to do it by mistake, in ignorance?"

"It was ignorance. Until you came in this morning I had no idea what the hell this was all about…. What is it, Audrey?"

Audrey Dopple was standing in the doorway, having forced her way past a protesting secretary. She had a copy of Alice's letter in her hand. She started to speak, then seeing me, stopped. "Could I have a word with you," she said to Fred. "It's very urgent."

Fred picked up his own copy of the letter. "This?"

"Yes. What are you going to do about it? I mean, serving on an appeals committee oughtn't to lay one open to this kind of thing, should it? I mean…" She stopped, waiting for an answer.

This was a good moment, too. Audrey Dopple is a royal pain in the ass whose particular joy it is to assume that she alone is charged with seeing the ethical implications of our acts. Every department has one. Sitting on the committee that judges the applicants for sabbaticals, she wonders out loud whether we shouldn't consider our duty to the department's budget, as well as to the applicant who wants a paid leave to write a book. "Ought we not to think beyond the question of an individual's request to the wider one of the community's needs?" she tends to cry.

I knew that Richard had been glad to find her on the committee he was sueing, because, once upon a time, in circumstances like these, a petition had been got up in the department by the permanent faculty in support of a part-timer who was being let go because of budget cuts. (They're not bad, these people. They'll do anything for us short of rocking their own boat.) But Audrey had declined to sign. I still remember the look of troubled saintliness she wore as she pointed out she was not "refusing" but "declining" to sign, an exquisite difference much appreciated by the man they were firing. Her reason then was that she did not know what financial pressures the administration were under, and such matters could not be judged as if they were absolute when the circumstances were relative.

None of the rest of the faculty knew anything about the financial pressures, either. They just liked the man who was being fired. Audrey Dopple went the rounds of the part-timers, explaining her position, with a little speech, beginning, "You won't like what I have to say, but…", thus creating a bracing moral stink about not only doing a painful duty, but showing that she did not flinch from telling the people concerned why the pain was necessary. Richard, a friend of the laid-off part-timer, had also not flinched from telling her what he thought of her, and she would have remembered.

She enjoys judging, prefacing every verdict with "I know I may be wrong, but..." While everyone else ducks committee work, Audrey is to be found on most of the committees concerning personnel matters. "Oh, God," she sighs, "not another one," shaking her head as she agrees to serve. She is large, blond, with huge cheeks like giant peaches, and with a coil of yellow hair over each ear. She ascribes her moral scruples to her inability to overcome the teachings of her Icelandic ancestors. "I wish I could agree," she says. "But I just can't see it your way. Sorry." A little laugh. "This damn Lutheran background of mine gets into everything."

I don't like Audrey, nor do most people, including Fred, our chairman. He took the chance of a few minutes' respite from his own misery. "You did volunteer to serve on the committee, didn't you, Audrey? I mean, this committee isn't part of your academic workload?"

"I think it's everyone's duty to..."

"Yes, but it isn't like the curriculum committee, is it, or the remedial English committee, where I can make you take your turn in the barrel?"

"The fact that it's voluntary ought not to make it different, surely?" Audrey has a good "surely", with about eight syllables in it, like Margaret Thatcher's.

"It may be a legal point, though. I don't know. I would think the university will stand behind you."

"They must!" A hint of panic crept into her voice.

"I think if I were you I'd consult your own lawyer, Audrey. I'm speaking purely as a friend, not as your chairman. Officially I can pass on your concern. Make it part of the university lawyer's file. Have you commented on the merits of the case yourself? In private? To anyone? I know how fair-minded you are. Did you think

the student had a case? Might Richard have heard something of what you think?"

It was very hard on her after all her years of being on the high moral ground, but she had it coming. She said, "I have never uttered one word of my opinion to anyone. How could I? I haven't even formed one. We haven't heard the facts yet."

Fred said, "I thought you were asking around the department if anyone else had taught this student before. Creating a fuller profile, you called it. You asked me last week if there had been any complaints of a similar nature against Richard. You remember? Here, in the office. I said that it was just like criminal law, that to know that might affect your judgement. Did you take it that I meant there was a history of complaint? I certainly didn't intend that. And by the way, weren't you on the original committee that laid down the procedures for handling complaints of harassment? As opposed to ordinary academic appeals? Along with Joe here? I seem to remember. Surely you should have realised this was incorrect procedure? You did agree to serve on the committee for Costril's complaint, didn't you?"

Audrey was now jerking her head back and forth from Fred to me, and before she could gather herself two more members of the appeals committee arrived in a panic, waving their letters from Alice. I left them to it. It was time for me to report to Ernie Hyde. First, though, I wanted to have a look around that apartment again, and learn a bit more about Hyde's world.

Chapter Thirteen

NOW I WAS working for Hyde, I probably could have conned the super into letting me in because it was unlikely that Hyde had told him to bar me; he would think that telling me would be enough. It seemed smarter, though, to avoid Albert if I could, so I called his number from a box in the street, using a Scottish accent this time, and learned from his wife that Albert himself was out for the day and the wife had a young child she couldn't leave, so if I wanted to see a vacant apartment I would have to come back in the evening.

I let myself in the front door with Helena's key. I was only

exposed for about three seconds crossing the lobby, then I was in the elevator and on my way up.

The apartment was still in the mess I had created, but I found what I was looking for in the bathroom, on the top shelf of the towel cupboard: the old container the VCR had been packed in. I stood on the toilet seat to lift it out. It came up a few inches, then held. I wiggled it about until it was obvious that something was holding it, like a fishing line caught on the bottom, and I treated it like a bad fisherman would, pulling hard until it snapped. I rested the box on the sink and took a look inside the cupboard. A thin wire disappeared into the wall. I was afraid if I pulled I might lose the chance of finding where it went so I left it for a moment and looked inside the box.

I was not surprised to find a very simple-looking audio recording device. Although it did not contain a cassette, a spare was lying in the bottom of the box.

I tied a knot in the wire, bigger than the hole in the wall it came through, leaving about three inches loose from the wall. Then I returned to the phone in the bedroom, found the jack it was plugged in to, and pried it away from the skirting board with a bottle opener I found among the kitchen implements I had tipped on to the floor. I returned to the bathroom where the wire from the recorder had now been sucked up tight to the wall. Someone had been taping calls, just as the Trinidadian had suggested. I put the tape in my pocket and left.

～

Next, I called the department, and the secretary gave me a message to call my old student, the stockbroker I had asked to find out about Hyde.

"Interesting, this," he said, when I got through. "Your man Hyde, owner of the Lunch Box. Not long ago the subject of an

article by a financial journalist. The Lunch Box annual report was out and the only complaint the auditors had was excessive wastage. Seems too much food was spoiled before it got to his customers. But Hyde says that little problem—the only one, remember—is corrected and that the company is in great shape, so the analyst gave it a strong 'buy' recommendation. Did I say he's pretty certain to be subject to a takeover bid by an Atlanta company? The shares have doubled since last year, and Hyde still owns half of them himself. It looks like a buy to me, too."

I thanked him, having learned nothing new. So what if Hyde was about to become three times as rich? What did that have to do with Rosie?

Before I left to see Hyde, I drove back to the political science department to talk to Barry Tucker.

"Barry," I said, sitting cross-legged in front of his ego, "can I ask you something in confidence?"

"Certainly. You understand that if your question leads to an area where I already have a professional interest, then it may look to you as if I've breached your confidence?"

I understood. He was telling me he really was an asshole. "But you will warn me?"

"I think I can promise that. Speak on. I did suspect something the other day, of course, but...well, let's have it."

"You know, sometimes, when I'm wearing my other hat, I'm asked to do a bit of surveillance."

"Yes?"

"It helps to know who I'm following, and why. It's less dangerous. Some of the people I have been assigned—well, you don't want to follow them too closely."

I held my breath. If Richard heard this he'd fall down laughing, knowing perfectly well that the greatest danger I've ever gotten

into is of catching pneumonia because the heater on my car has broken down.

"Of course," Tucker agreed.

"I'm on a job right now that worries me. I'm following a man and I don't know why."

"Who?"

"Councillor Goodfellow."

The legs of Tucker's chair were lowered to the floor. "What for?"

"That's what I'm saying. I haven't been told. I don't know who my employer is. Maybe his wife. Maybe his girl-friend's husband. Or just maybe somebody dangerous. I'd like to know what kind of man I'm watching, and what he might do if he finds I'm watching him. See?"

Tucker said, "I don't see what I can tell you—"

"You're in touch with the inside gossip," I cut in.

He nodded. "Some."

"So who's trying to trip him up? What's his secret? Is it personal, or is he up to something down at City Hall? What is he involved in that would interest anyone else? Is there some important committee he's on, some big vote coming up? Is he on the take?"

I stopped. I was beginning to slip into my Irish impersonation.

"I'll find out what I can," Tucker said. "And when I do, I'll tell you. Then I may go my own way. You understand? If this turns out to be hot, then I'll feel free to use it."

"Understood. But tell me first."

~

"Go over this again," Hyde said. "Where exactly were you picked up?"

We were sitting this time in Hyde's den, a room that contained a pool table and several exercise machines as well as armchairs

and couches to accommodate a dozen people. It was late after-noon, and once more Jackson had brought tea as a front for the whiskey we were drinking, or rather, had drunk, because once the Jameson's was poured (and this time I was quicker with my "yes") Hyde required that it be thrown back against the tonsils and all the evidence put away. I have never known a man in such thrall to his wife. He was like a little boy who has perfected a technique for stealing food from the fridge.

I told him the story, from getting the call to being picked up in the car, driven around, then dumped, with Rosie's picture, back at the starting point. I explained to him how the casually dropped word "tape" had led me to the conclusion that Rosie's apartment had been bugged, and then to the further conclusion that it was the tape he was being blackmailed with. I didn't tell him about the tape I had found.

He listened and made no comment about the tape. "Show me the picture," he said. I showed him the Polaroid picture. He looked at it, nodded, then something caught his attention and he brought the picture up closer to his face. "This your hat, you say?" he asked again. I confirmed it.

"How long was it between being picked up and them dropping you off?"

I had wondered about this myself. "Long enough to develop a Polaroid," I said, answering his real question.

"So they put your hat on her, took the picture, then drove round until it was developed, then passed it to you." He nodded to himself, then said piously, "I'm glad they haven't hurt her. Yet."

I wasn't sure what to do with that "yet".

"What you getting at, Mr. Hyde?" Jackson asked. He had stayed in the room on some understanding with Hyde, draped against the wall.

Hyde said, "I'd expect someone who'd been held captive by a couple of nig-nogs for two weeks to look a bit worn, at least. Show a bit of evidence she's been abused. But this one looks as though she's just trying on a hat. No bruises, nothing." He threw the picture on the table. "Looks pretty much herself. Take a look."

Jackson said, "These, er—black guys—don't sound like thugs, Mr. Hyde. Maybe they only took Rosie with them because she caught them removing the tape."

"Mebbe so," Hyde said. He turned to me. "So now you know. It's the tape, all right. I didn't see any need for you to know before, but you've found out now. Right. It's the tape they're holding over me head. That's what I'm after."

"What's on the tape, Mr. Hyde?"

"Didn't they tell you?"

I shook my head.

"But you have to know, do you?" He looked at me from under his eyebrows, with what I imagined he thought was a guileless, shy air. "Well, I'll tell you. It's me talking to Rosie. See, I couldn't always meet her when we said, and when I couldn't I used to call her, tell her things. Everybody has their peculiarities, Joe, and mine is that I get a bit of a kick out of talking a bit racy on the phone to me girls. I prefer the real thing, of course, I'm not a pervert, but I do enjoy a bit of the other. Telling Rosie what I'd like her to wear the next time I came to the apartment, what I thought we might do, that sort of thing. Nothing to harm anyone. She didn't mind; that's what I paid her for."

"And now it's all on tape. So who cares?"

"I care, and for the same reason as before, you stupid git. If my wife gets hold of that tape, I'm done. So go and get it and her, too."

No one moved.

"Go on," Hyde shouted, suddenly beside himself. "Find her, and find the fooking tape. Somebody must have seen her lately. Near Adelaide and Spadina. Find her." He turned to the bar, looking for the whiskey he had already put away.

Jackson whispered something in his ear, and Hyde thought about what he'd said. Then he turned to me. "I've changed me mind. You've done a good job and I thank ye for it, but you can quit now. I'll find her meself. We will."

I said, "When shall I come back for my money?"

"Your what?"

"My per diem. I figure you owe me eight hundred dollars so far."

"Ah, yes, well. Here's fifty. That's all I've got on me now. I'll send you the rest. All right?"

I shook my head. "No. Never mind the money. I don't like this. Tomorrow I go to the cops."

"And tell them what?"

"The whole story. Right down to seeing her yesterday."

"Why tomorrow?"

"Gives you time to find her. You can talk to your contacts in the area, starting with the cab-drivers. You'll find her. If she hasn't re-appeared by this time tomorrow, I go to the cops. This is kidnap-ping we are talking about. Obstructing justice, for me. Seven years, at least. So here's her real name, her address, and her tele-phone number. She's not there now, of course, but it will be handy to know who you're looking for."

Hyde took the paper from me. He looked up at Jackson. "He's done a fookin' sight more than you have, hasn't he? Never mind all your cabbie contacts. Now see if you can find her." He thrust the paper at Jackson.

"My money, Mr. Hyde?"

Hyde looked at Jackson for help. Jackson took me by the arm and led me out to the hall. "Wait here a minute," he said.

He went back into the room. Ten minutes later he came out with a wad of money in his hand. "Eight hundred," he said. "And two hundred for luck. Let's have a little loyalty to the guy who pays you."

I took the money. "I still go to the cops tomorrow."

"Give us a couple of days. Three."

That seemed reasonable. "You be in touch," I said. "I figure she'll be all right until then."

Jackson nodded. "As the man said, it doesn't look as if anyone is hurting her."

I drove home to dinner, uncertain of my next move. Having uncovered Hyde in one lie, I wondered again how many more he had been handing me. I wondered why Hyde didn't want my help—I was obviously pretty good at the job so far. And I wondered what would happen if I looked for Rosie a litle bit more, my excuse being that all along I had also been working for Helena. And I wondered also about Jackson. The sheer size of the guy and the fact that he had let me fall out of the car the first time we met had prejudiced me against him. I wondered now if I was being sizeist, because Jackson was getting more complicated. The little hesitation over the kidnappers, the reluctance, apparently to join Hyde in calling them "nig-nogs," suggested that he lived in a world less black-and-white than Hyde's. And Hyde obviously trusted him to understand the delicate relationship that existed between himself and Councillor Goodfellow. It all added up to the fact that as well as bodyguard, Jackson had the status of an associate, or at least, right-hand man of Hyde's. Someone to keep an eye on.

On the way home I played the cassette I had found in the

apartment. Once the tape was rolling I learned all it had to offer in the first two seconds, although I sat there and let it go on quite a bit farther.

It was blank.

~

At home I was amazed to find Carole bustling—it's the only word for it—around the kitchen. For her, the kitchen represents a challenge: how can she spend as little time as possible in her least favourite place and still eat well? Her solution begins with the choice of something that requires only the addition of heat—something frozen, obviously, but not obviously frozen. Carole has taste-buds, she likes good food, and one day when I'm rich we'll employ a cook, but at the moment she is constantly searching to solve the problem of trying to cook nothing and eat well. Some frozen food is acceptable, but all canned food, with the exception of red cabbage, is forbidden. So we eat a lot of vegetables that do not require being scraped or peeled or sliced thin or diced, e.g., green beans, tomatoes, and small potatoes, and any meat that can be grilled (lamb chops above all), microwaveable fish, and pasta, lots of pasta, because frozen pasta sauce is allowed.

For my part, early in our relationship I realised I was going to have to contribute more in the kitchen than I was equipped to, so I developed a repertoire of six dishes; three summer dishes: gazpacho, salade niçoise, and hamburgers; and three winter dishes: minestrone, clam chowder, and hamburgers. Come to my house on a night I'm cooking and you'll get one of the above, preceded by bruschetta in summer, and high-bake crackers spread with olive paste in winter. I started with the gazpacho and the clam chowder five years ago and I'm getting sick of them, as is Carole, but I haven't found any replacements yet. The others are holding up well. For variety I call in once a week to the

frozen foods section of Marks and Spencer, the clear leader in the field.

So I found Carole not exactly galloping, but definitely trotting about, with three saucepans steaming and the light on in the oven, just like a proper wife. I tried hard to respond, to fit in. I smacked her bottom and lifted lids to taste the contents, uncovering two vegetables that had been scraped and some peas that must have been shelled by hand. In the oven a meat pie burbled brownly.

"What's going on?" I asked. I was afraid she had decided to leave me, there being no other crisis I could think of that would bring on a reaction like this. I had in mind the way she had left her husband, long before I met her. The story was waiting for me on the grapevine when I first met her. One night, I heard, she had invited two other couples to dinner and gone to some lengths, with the assistance of an up-market take-out food shop, to prepare an elaborate dinner, cassoulet or some such. With the guests seated and the serving dishes steaming on the sideboard she called out from the kitchen that they should start, then left through the back door, taking the bag she had packed ready, and hailing a cab from the end of the street. As the story came down to me, it seemed to speak of a nervous breakdown. Now, though, I know that her husband had just gone too far in the hovering-around-afraid-that-the-dinner-wouldn't-happen-properly department, and she had simply finished preparing one last feast as a gesture before filing for divorce. Was she doing it again?

"Arlette and Berky are coming for dinner," she said. "That's them now. Get the door."

That was all right, then. If she were planning a pre-flight demonstration she would have invited friends of mine, not her sister and her husband.

"Why?" I asked. It was only six days since we had dined with these two. The proper length of time was a month.

"We're going to a show at the art gallery. You don't have to come."

"Good. I won't."

I was perplexed. Carole knows less about art than I do, and cares about as much. We have some framed prints on the walls, a witty poster by Sempé and a cartoon by Hogarth, but only because of the convention that walls should have pictures on them. Left to myself, I would leave the walls bare, or conceal my lack of taste by decorating the apartment with what I believe are called genre and narrative pictures; *The Boyhood of Raleigh* and *Stag at Bay* would be prominent. I would try to find that set of pictures of dogs playing cards—anything to make the guests wary in case this stuff was suddenly "in," or I was being witty. People of culture sneer at other people gauche enough to have framed Impressionists on their walls, but they are nervous of judging someone whose professedly favourite picture is entitled *When Did You Last See Your Father?* or *The Emigrant's Farewell to His Homeland.* Carole dislikes cobwebs, but otherwise cares no more than I what is on the walls. So what was this new interest in art galleries about?

"Fine," she said, with no apparent edge to her voice. "You can stay home. Now let them in."

The pie, after all, turned out to have come from a bakeshop, and it was good, and there was gravy for the potatoes. We had a fruit salad, which Carole had cut up herself, then Berky said, with what I later realised was elaborate nonchalance, "I think I'll give the gallery a miss, too. You girls go ahead. Maybe Joe will bring out his cognac and we can watch the ball game."

So, much of this should have alerted me to the fact that something peculiar was going on. There was Carole cooking, Carole

going to an art gallery, Berky *not* going to an art gallery, which he likes to do, go, I mean, and finally Berky suggesting we watch baseball, albeit while drinking my cognac.

Chapter Fourteen

I HAD NO cognac, of course. That was just bullshit. Who has, after Christmas? We made do with a glass of L.C.B.O. Extra Special economy-priced Scotch without water, and a cup of coffee. I was hoping Berky would go home soon because I wanted to get up to the Iron Ore House before the evening was over. But Berky had something on his mind and he started right in. "Maybe we should take advantage of our evening off," he said. "Have a night on the tiles."

The idiom should have alerted me. The phrase "night on the tiles" was too jaunty for Berky, and it wasn't what he meant,

anyway. He probably got it from Wodehouse. "How do you mean?" I asked.

"Don't you ever feel like expanding your horizons?" He winked. "Sexually, I mean," he added, in case I thought he had something in his eye.

"Have an affair, you mean?"

"Nothing so grand. Just a bit of something different. Don't you have any secrets you don't share with Carole?"

"What kind of secrets?"

"Oh, you know. One of my patients is stimulated by ice. When he gets a chance he buys a block of ice from the gas station."

"What does he do with it?"

"He makes love to it, then puts it under the hot tap before his wife comes home."

"The ice?"

"Yes, of course. He likes women, too, but he says a block of ice is a treat."

"Does he have Inuit blood?"

He laughed. "Racist! Seriously, you'd be amazed at the range of little jollies my patients indulge in." He winked again.

"No, I wouldn't. The wisest thing I ever heard was from a guy in graduate school who said, if I can imagine it someone is doing it."

He hit the ball back into my court. "What do you imagine they've been doing this week?"

I tried to remember the stories I had heard from medical students, then I thought of something an old Arab I knew used to say. Jokingly. "Melons?" I said.

"What?" He seemed taken aback.

"Melons. You know the old Arab saying, 'For ecstasy, try a melon.' "

"No, I don't. Have you tried one?"

"Of course not. It's just a saying. Nor have I tried a block of ice."

I added *that* because I thought I might have a problem on my hands. It was becoming clear that Berky wanted to share experiences with me, fantasies, at least, that I had not experienced. I had always suspected that this could happen to psychiatrists. They trade in patients with problems, kinky ones many of them, and they must lose any sense of what mundane furrows most people still plough: domestic, well-tilled, and *straight*. And it seems likely that from time to time they, these psychiatrists, will hear of an aberration that creates a faint echo in the depths of their own chambers—as it might to any of us if we had their opportunities, let's be fair—so that, alone, when the day's work is done, when the wife is at a movie with a girl-friend, they will stop off at a gas station on the way home for a block of ice, just to try it. This, I judged, was happening to Berky. He had been tinkering with his tastes and now he wanted company, a shared confession that would allow him to include his new indulgence within the realm of the acceptable, even for a shrink. The hell with that.

"No," I said. "No ice, no melons, and while we are on the subject, no vacuum cleaners, no sheep, no goats or cows. Just Carole."

I had intended a slightly raucous catalogue of the common fetishes I did not have in order to finish with the subject, but he was persistent, badly in need of a secrets' sharer.

"How about porn?" he asked. "Videos, for example?"

"I don't bother."

"They don't turn you on? At all?" There was a gleam in his eye.

I'd had enough of this. "Of course they do. Movies of people involved in sexual acts create two reactions in me. First they prick

my lewd priapus up, as intended, and second, I look at my watch almost continually. Guilt and excitement thus create anxiety, which I don't need, and since I also don't need the stimulus of pornography I leave it alone as neither therapeutic nor ultimately pleasurable. How about you?"

"Do you find erotic photographs—er—erotic?"

"I asked you first."

He laughed in an unconvincing show of casualness. "So you did. No, I'm still wedded to the printed word."

Did he mean art or grunge? *Madame Bovary* or Krafft-Ebing? *Lady Chatterley* or *Fanny Hill*? I couldn't ask without prolonging a discussion in which I felt increasingly the presence of a very large hidden agenda.

He continued to press. "So you are able to give full expression to all your sexual fancies? At home, I mean?"

Now he had just gone one step too far. We didn't know each other well enough for this. "All my sexual fancies *concern* Carole," I said.

But he missed my withdrawal. "Aha," he said, or something very like it. "You mean you don't allow yourself to imagine anything Carole would find distasteful?"

Now we were second-year undergraduates. Pretty soon he would be asking me when was my first time, and I was a long way from confiding anything like that to Berky. It occurred to me that after a day of listening to his patients unseam their minds, he couldn't possibly be interested in more of the same from me, and then I realised what was going on. It still wasn't how I wanted to spend my evening, though. Just to be sure, I said, "I would guess those two sisters we live with have enough genes in common for you to know the answer to that, eh, Berky?" I arched an eyebrow. He shook his head ruefully and I knew I had hit the mark.

Nevertheless, whatever Carole and Arlette had in common, there was no consanguinity between Berky and me.

I changed the subject. "I've been wondering about the movement towards drug therapy to replace the kind you're into," I said. "You know what I mean. With all the new emphasis on drug therapy as an alternative to the couch, could it be that one day soon there'll be a whole range of drugs that will enable one to correct or modify or even induce any aberrant taste? I mean, soon you should be able to create a shoe fetish with a couple of injections, or overcome a distaste for oral sex with a beta-blocker or whatever they're called, three times a day."

I was running out of gab, but I had done enough. He had been dying to interrupt my ignorant prattle from the first sentence, and now he did, lecturing me for an hour on what I thought I was talking about, playing with the possibilities I had raised, showing their logical absurdities, discoursing on the differences between the body's chemistry and psychology in analysing a patient's needs. He was still talking when the women came home, or rather when Carole came in alone. Arlette waited for Berky in the car, and I followed him out to pay a visit to the Iron Ore House.

～

I had wanted to find some one of Rosie's colleagues who might have some clue to where she hung out and who with. The barman called over a girl named Tempest who agreed that she knew Rosie as well as anyone, but pointed out also that she was working, so I had to pay for a table-dancing session if I wanted to ask her any questions. It turned out to be a con: Tempest knew nothing about Rosie's life outside the Ore House except that she went to college. The table-dancing wasn't much, either. The perspective was all wrong.

When I returned from the Iron Ore House, I told Carole what I thought.

"Your brother-in-law needs help," I said.

She looked at me in this new way she had developed, wary, but determined not to run away.

I said, "He spent the whole evening trying to find out what perversions we had in common so he could confess his. I think his job is getting to him."

"Did you tell him?"

"About what?"

"About you."

"Us, you mean? What's it got to do with him how we do it?"

"Not us. You."

"Me? I don't have any, er, life, beyond you. It's obvious he does. That's what I'm saying. He needs help. Tell your sister to watch for the signs."

"What signs?"

"How the hell do I know? *She's* the shrink. All I'm saying is that Berky can't keep his mind off his work."

"I'll mention it. That you said that, I mean." She slid into bed on the far side, and lay there without closing her eyes. When I tried to plump my pillow, fifteen minutes later, she was awake still, watching me.

～

The next morning, a Saturday, I began the search for Rosie. Like Hyde, I had drawn the conclusion from the picture that no one was hurting her, and added my own that the picture had been taken and developed while I was being driven round and round the area in an attempt to create the impression that Rosie was miles away. In fact, she was probably being held within a block of the corner of Adelaide and Spadina. I added to that Hyde's comment, that her unspoiled look meant that she had been persuaded to "come quietly" as the bobbies say, and that possibly she had

been seen quietly escorted by her captors from car to hiding place. In other words, nothing was making much sense, and I decided that a day or two looking for her wouldn't hurt.

I checked my machine for messages from the night before. There was one, to call Barry Tucker, at home if necessary.

"Barry Tucker," he said crisply when we were connected. "Can I help you?" He was practising in case he ever got a phone-in radio show.

"Joe Barley," I responded, crisply enough, considering the lack of hard consonants.

"What? Oh, yes, right. Here it is, then. First, the only committee that matters is the Buildings' Committee. Over the years, building permits have been the cause of more corruption than any other single area of Council responsibility."

"So what has Goodfellow been voting for lately?"

"I think it's the upcoming business you should concentrate on, surely."

"Fair enough. Where will I find that listed?"

"The applications are on file down at the Hall."

"I don't know what I'm looking for, though, do I? I suppose it might come to me as I read through the list?"

"Be a bit of a job."

"Anything else you thought of?" It seemed to me that what he had told me was so blindingly obvious that it wouldn't sustain even a juvenile mystery.

"Not yet."

"Then try this. Finding out what Goodfellow is voting on is not much use in itself. It's his job to vote for or against everything, right? And it's perfectly legal for the people with an interest to try to persuade the members of the committee to vote for their projects."

"It's called lobbying," Tucker explained.

"But what isn't legal is taking money for favours, right? So what I need to know is who might be bribing Goodfellow."

"That's why you're watching him, surely."

"So it is. But is there any legal requirement for Goodfellow to report a donation to his campaign fund, for example?"

"Of course."

"Could you get me a list of donors for the last campaign?"

"I think so. I'll see what I can do."

"I'd be grateful."

~

At nine-thirty I began at the drug store on Spadina, looking for a trace of Rosie. I carried her picture with me to accompany the story I had developed, that I was her brother over here for a visit from the old country, had lost her address but knew she lived in the neighbourhood.

I worked the shops, the cafés, the pubs of Adelaide and Spadina until noon. By then it was clear that there was no point in asking further. Everyone had seen her, always in the company of one or two men, if not the day before, then the day before that, sometimes both. In the short time that Rosie had been abducted, she had made the neighbourhood her own, with a cheery smile for everyone. Several of the café owners suggested that if I stayed still for an hour I would see her for myself, so I took a stool in the window of a café, and watched the street all afternoon. There was no sign of her. Then about five o'clock, just when I was wondering what would sit on top of three coffees and two bottles of beer drunk alternately at half-hour intervals, the bartender called over. "Mr. Barley? Joe Barley?" He held up the phone for me.

It was my friend, the West Indian. "Listen," he said. "Will you fuck off? If you don't, you'll get hurt. So will Rosie. She's not

around here any more so there's no point in sitting in that damn window all day. Go away. This is between us and Hyde. You get in the way, you get a…" he paused to think of something suitable "…a banana-knife up your ass." He hung up.

I could imagine a banana-knife—big bugger with a curved bit at the end. Still, I couldn't stop now. But the time had come for a long think. There was a lot to sort out before I could know what to do next.

Evidently I was wasting my time looking for Rosie. Her abductors knew me, had seen me, and were keeping her under cover while I was around. And if they hadn't already moved her, then they certainly would as soon as I left.

Another message: none of the store-keepers who had reported seeing Rosie in the company of one or two men had said the men were black. You could believe that integration was so successful that no one noticed colour any more, but you'd be a fool if you did. Public tolerance is high in Toronto, but privately most of the people I spoke to would have brought enough prejudice with them from the old country to have registered the colour of Rosie's companions automatically and reported it to me.

The second thing that I had to think about was that they knew who I was, to see, I mean. It was possible that one of the local vendors, not believing my story and feeling more loyalty to Rosie than to me, had seen Rosie and her guard(s) after I had enquired and told them I was looking, and they had tracked me to the café. Perhaps they had been watching me all afternoon, until finally they made the call. But why? Why not move Rosie across the city? The answer was, I realised, that by sitting in the window of that café I had bottled them up, got between Rosie and her guard, or between both or all of them and their car, which was probably parked on the street under my nose. And all the time I was

accounting for one thing, I was postponing the crucial question: How did they know my name? And when I finally thought about that, two things became clear. They knew me, and therefore I knew them, or one of them. What I had to do now was look as if I were obeying their orders before I made my next real move, probably the following morning.

I stood up in full view of the street, straightened my tie, searched in my wallet for the money for the bill, all to give them time to get in place and follow me if they wanted; left the café, walked to the parking lot, drove slowly over to Spadina and made my way home, making no tricky moves in the traffic. No one followed, or rather, the post office truck, the purple Oldsmobile, the black Jetta, and the pickup full of lawn mowers stayed tightly in place behind me in the single file that construction on Spadina Avenue reduced us to, and they all disappeared north of Bloor. It could have been any of them.

Chapter Fifteen

THE REST of the weekend was uneventful if you don't count Carole's continuing extraordinary behavior in bed.

I had some tests to mark, tests which had been promised to the students for the next class, and I burned my way through them on overdrive. I was finished by ten on Sunday evening without the faintest idea of what I had been reading, but quite sure of the accuracy of my grades. I sorted out the three highest grades to reread to see why they were so good, and decided it was time for bed. I had a lot to get through the next day. I became aware then that I was still being watched or rather waited for by Carole, who was in the living

room, pretending to read. When I came out of the office, she set down her book immediately and moved to make some tea. "I'll bring it in," she said. "You go ahead." She smiled. "Don't go to sleep."

This coyness, never seen before, totally out of keeping with the Carole I knew, behaviour, which if she had seen it in a sit-com would have made her throw up, should have warned me. But dazed with the essay-marking, I registered only that the day seemed to promise the old kind of ending. Certainly we began in familiar fashion, unanxiously, ruminatively, and then sliding together and gathering to a peak before the run for home, enjoying ourselves without quite abandoning consciousness—that's for holidays—when Carole curled her fingers around my bum and raked me deeply with eight fingernails, sharpened, I found out later, for the purpose. It felt as though I had suffered one lash from a cat-o'-nine-tails strung with white-hot barbed wire.

"Jesus Christ," I shouted, or something like that, simultaneously withdrawing, coming, and grabbing myself behind to stop the blood. "What the hell are you *doing*?"

"That seemed to work," she said, looking down at herself, surveying the swamp. "Hand me the Kleenex."

"Fuck the Kleenex," I continued to shout. "*I* need the Kleenex first, and then some stitches."

She pushed me over and examined the wounds. "No actual blood," she reported. "Now give me the Kleenex."

"But what were you up to, for Christ's sake?"

"I read about it in a John O'Hara story. The hero of the story liked to have that done to him, and I thought you might like it. O'Hara's hero didn't want to talk about it in case it meant he was a pervert, but that was in the forties. It's okay now."

"Yes, nowadays I don't mind talking about it, I just don't want you to do it."

"It worked, though! You can't say you were indifferent. You came a gusher!"

"Try this," I said. "One difference between men and women is the phenomenon of premature ejaculation. I don't know if women can have something similar, but it wouldn't be so concrete, at any rate. Now, premature ejaculation is just what it says, an aberration, a breakdown, an interference in the act. It aborts it, okay? Common among adolescent boys in their first encounters with girls, though becoming less so nowadays, I wouldn't be surprised. It was always understood that PE, let's call it, was a product of acute excitement, especially, among the young, of the 'God-I'm-really-going-to-get-laid' kind. But there are other causes. One, very common in Victorian times and wherever they have survived, is the one occasioned by self-loathing when the male, trained to see woman in all her chasteness, finally comes face-to-face with love's mansion, as Yeats calls it, and is appalled by what he wants to do. The PE gets him off the hook. Something like this, I think, is what just happened. The only way to stop you from tearing the skin off my ass was to make it unnecessary. It worked, all right, but for all the wrong reasons. *Everything* went wrong. Look."

I sat back on my heels to show her.

"What's wrong with that?" she asked. "I thought you were proud of it."

"The point is, it is unrelated to my nervous system. For all I know, it will never go down again."

"How will you go to work?"

I fell down beside her. "I'll worry about that in the morning. Do you understand that you have dislocated the cause and effect of my sexual mechanism? Why? What in the name of God is this all about?"

"I want to make you happy," she said. "I mean 'content.' It's

peaceful here with you, so I don't want you to go away. That's love, isn't it? I know you would rather I were a gourmet cook, and a good hostess, and a gardener and decorator, but I can't do any of that. I thought you didn't mind too much because you are kind of useless yourself, except at your job, so I thought we could live and let live, as we have, haven't we? But if it didn't work, it would have to be because it didn't work in bed, and *that* was always all right. I mean, I was good enough there, wasn't I? You were, for me. Anyway, after we got together, I had no interest in anyone else, ever, and I thought you didn't, either. I thought we were generally on the same wave-length, or frequency, and if we ever weren't, the other one was always obliging, if you or I weren't too tired. Isn't that so?"

She was right. We were content. Amazingly so. We never had talked like this because we had never needed to. I said so. "Until lately," I said. "When you became very strange."

"I was just trying to divert you from what I thought you were into. Weren't you?"

"What? What? What?"

She was on the brink of telling me, then she clammed up. "That's a bad idea," she said, as if to herself. Then, to me, "I just want you to be happy." She was crying now, large, silent tears that looked as if they belonged to someone else.

"You could start by clipping your nails." Believing her, I felt a surge of love, which, while it filled my heart, drained me in all other amorous respects, but that was all right because I was then able to embrace her with a limp purity that confirmed I was embracing her for herself alone and not as the start of some new enjoyment. I stroked her flank, and she looked at me queryingly, but I made it clear that there was no more to come but lots of stroking, and suddenly she snuggled close in my embrace and soon went to sleep. Temporarily we were one again, but there *was* more to come.

~

The next morning I woke feeling as if I had been severely caned the night before, and I was that much in Carole's debt for the discovery that the pain carried no overtones of remembered sexual pleasure. I suppose you have to start that sort of thing early, in an English public school, to be properly addicted. Certainly, I could cross it off my list, along with necrophilia, coprophilia—in fact, all the *philias* (but nothing ending in "us" or "o"—they're all right).

Now I had to teach. I was just about to deliver my concluding remarks on the *Odyssey*. These were identical to my introductory remarks: the difference was in the students, who had now read the poem or some of it or had heard about it from me, and were therefore in a fitter state for instruction than they had been three weeks ago. I also wanted to find out how Richard was making out.

Barry Tucker waylaid me in the corridor outside my office. "Here we are," he said, handing me a sheet of paper, headed CAMPAIGN CONTRIBUTIONS: COUNCILLOR GOODFELLOW. "But I should tell you that I have matched them up already with the list of applications for building permits. None of them match. If he is being bribed, it's not clear who is benefitting."

"That's why I'm watching him, I guess. Thanks, Barry."

"If anything murky does surface, you'll let me know?"

It was on the tip of my tongue to point out the mixed nature of his metaphor, but that way lies unpopularity. "You'll be the first," I promised.

~

Richard and Alice were in the office. He looked up to tell me to get out; that is, to tell anyone except me. When he saw it was me, he said, "They tried to suspend me."

I'll always be proud of my reaction that day. Richard looked distraught; even Alice seemed concerned. I was shocked, and then

realised immediately that to show my reaction would only worsen the situation. I nodded, trying for the expression novelists call "grim satisfaction." "I expected this," I said. Then I realised that with some part of my brain I *had* been expecting something. This was a ploy. "They took a look at Alice and decided to show they're not frightened. They are. They are also confused. What's their excuse?"

Alice said, "They say they wish to lower the temperature. The whole issue has become over-heated, they say. Coolness is needed. Richard is exaggerating. They didn't use the word *suspended*; I did. When I asked them if they were going to publicly suspend my client as well as publicly try him, they backed off. Not at all, they said. No question of suspension. They just meant that this must be a great strain on him so they would understand if he wanted a few days off. But you're right. They thought to frighten us."

"They are scared shitless. What did you say, Richard?"

"I said I was fine, thank you. But I'm not."

"Hang in there. We've got them on the run. How did this come about?"

Richard said, "Last night I received an informal call from the registrar offering to mediate as a friend, if I liked. He suggested I get rid of Alice and go back to square one."

"Is he a friend? I thought you couldn't stand the guy."

"I can't. I think he meant 'friend at court.'"

"What's 'square one'? You, on a charge of racism?"

"He said he could guarantee the outcome of the enquiry into the student's complaint."

"I expect he can, but as we said at the beginning, mud sticks. The headlines in the *Hambletonian* will be COSTRIL BEATS RACISM RAP, or better, ADMINISTRATION LETS COSTRIL OFF CHARGE OF RACISM. The students will know you are really guilty as hell and that the dean packed the jury. The point is, if this hearing goes

ahead, you will come off badly whatever the verdict. We've got to frighten them back."

"How?"

"Make them see they will wind up with a hell of a mess if they even think of conducting a public trial of a matter as sensitive as this after being warned. I think we can paralyse them. I mean, here we have a chairman, a dean, a vice-president, all having fucked up, all feeling their necks. By the way, what do you want out of this? Money?"

Richard said, "I don't think so. Money is risky. Everyone would envy me. No, my job. And an apology I can wave about if they try it again. That's it, a large public apology. They'd never be able to get rid of me then."

"Better get your legal costs, though."

"I'm not charging anything," Alice said. "I'm just doing this to pay off an old debt to you, remember?"

"Don't talk like that, Alice. You sound like an accountant."

"Sorry. No. We'll never be even. I'll always be in your debt."

"That's better. And Richard in yours. You can never pay off these little acts of kindness and of love, as Wordsworth called them. You can just be enriched by them."

Richard said, "I've never heard you talk like that at this time of year. Ah, yes. Of course. Not Wordsworth. It's the wrong season for Wordsworth. You've been preparing Dickens again, the great tear-jerker."

I said, "No. It's the presence of Alice here. She brought the simplicity of a Caribbean Sunday school into my classroom, and for me there'll always be that echo when she's around, whatever the source of her new power."

"Lawdy, lawdy," Alice said. "Dat man could talk a 'possum out of a tree."

Richard said, "Don't do that, Alice. It would be impossible for someone hearing that sentence as they came through the door to deconstruct it and keep his balance. They would have to know the particular you, your audience, the complex relationships between you and us, your background, your capacity for horseplay, and your genuine admiration for Joe. Keep it simple."

"Can't help lovin' dat man," Alice said. "But, okay. I was just jazzing around, trying to head him off from saying what a cute piccaninny I must have been. It don't decode beyond that."

I had to go. I left them and drove down to City Hall, where I examined the applications for building permits. I had, of course, left out one vital piece of information in my chats with Tucker, and I was pleased to find a reference to it almost immediately. Planning permission had been requested by Lunch Box to expand their activities over another couple of acres along the lakeshore. There was nothing fishy about that, or rather there was, but I could not see why yet, because, according to Tucker, neither Hyde nor Lunch Box had made any kind of contribution to Goodfellow's war chest.

What I needed now was a crew of assistants. Jackson, Hyde, and Goodfellow all needed to be followed, and pictures taken of everyone they met. The offices of Lunch Box needed to be broken into, ransacked, the books stolen and photocopied, the copies to be handed over to a firm of forensic accountants. This was for starters. I sat down to think of a feasible alternative. I mean, just having Jackson, Hyde, and Goodfellow followed would cost at least five thousand a week. Unlike the PIs in fiction, I know the going rates.

The possibility of a solution came through my student connections again. I called Ulo Jensen, a man whom, like Alice, I had once done a favour for. (I had perjured myself in court on his be-

half back in the days when possession of marijuana was a hanging offence. His defence was bald and bold—he was simply doing two friends a neighbourly turn, he said. Friend A had asked him to give Friend B a book, as he lived nearby. He had no idea that the pages of the book had been cut out to create a pocket for transporting several ounces of dope. As soon as the cops nabbed him and showed him what he was carrying, he knew it was marijuana, of course; he had often seen it. But he, personally, never touched the stuff. He was simply passing on a book. This was his story and I testified truthfully that he was one of my best students and was probably telling the truth. Ulo got lucky: that day the judge had been irritated by the cops and chose to irritate them back by finding a flaw in their methods, and Ulo was dismissed. He gave up dealing dope, which was how he paid his way through school, and took to dropping in on me when he was in the neighbourhood. Now he worked for the CBC, a staffer on one of those investigative shows.)

I called him up and told him my problem. "I need some help," I concluded, "someone to tell me how to find out what goes on down at City Hall, what *really* goes on, I mean."

"Everybody knows *that*," he said. "But I'll have you meet the source. I don't believe you ever taught this guy. What's your number? Keep tomorrow free, around five. If you don't hear from me before tomorrow noon—you got voice mail?—I'll bring the man you want to Eggy's at five. That's a pool-hall on Richmond. You play? I mean, you know why one end of the stick is narrower than the other? Okay. I'll call you back."

~

My next move had to be made incognito, and to start with I swapped vans with Richard, who drives an old Chevrolet van. After a sandwich in the cafeteria, I went to work. I needed to get

hold of the missing tape, because I was certain by now that there was more to the tape than simply Hyde talking dirty.

That Hyde was a liar I had never doubted, but my real concern grew out of something that had puzzled me from the beginning: In simple terms, the strange response of Rosie to the ringing telephone. Helena had said that the phone almost never rang when she was there, and if it did, Rosie never answered it. Her indifference made no sense of a hot-breathing Hyde, eager to fill her ear with filth. Surely Hyde would require some reponses to his chat, some reciprocating dirt from Rosie, and from what I'd seen of her pictures, Rosie was certainly up to it, I would think, though maybe not when Helena was within earshot. (The two were close in age, but Helena, for all that she had watched morning TV with Rosie occasionally, was still an innocent from a Portuguese farm, culturally not in the same class as the table-dancer. Rosie would not have wanted to shock her.)

But it was an unsatisfactory explanation. Rosie could not have known that it was always Hyde at the other end. If she used the phone at all, then calls might have come from anybody. And how could she distinguish between a stimulated Hyde and a Hyde simply calling to tell her he would be late? And it would have been easy enough to tell Hyde, whatever condition he was in, that Helena was there. So why didn't Rosie answer the telephone? Quite simply, because it wasn't her phone. It wasn't her apartment, and we've all been in circumstances where it is more courteous not to answer our host's phone.

It seemed to me, then, that the explanation was that she did not answer the phone because Hyde had told her not to. In which case, who was on the tape? Not another table-dancer. Who, then? Hyde needed to be looked at a little more closely. First, though, I had to make one more try to find Rosie.

Chapter Sixteen

I SAT IN the window of the café most of the afternoon. Then, around five o'clock, a kid, a boy of maybe ten or eleven, slipped through the door and came over to me. He didn't say anything, just pulled on my sleeve. I gave him a quarter, which he took, then he pulled some more on my sleeve. He reminded me of a Gypsy kid who attached himself to me in Paris once when I made the mistake of giving him some money and followed me across the city for two hours asking for more. I thought I had another one on my hands, then this kid said, "I'll take you to the lady, mister. Gimme five bucks."

It couldn't be a con. How did the kid know I was looking for a woman? I gave him the five dollars and we left the café together, the kid slightly in front like a guide dog. He led me back along Adelaide and then turned into the alley where my van was parked. We passed the van, then the kid suddenly turned the next corner and disappeared. I had a second or two to wonder if that was that when an arm came round my neck in a firm, friendly fashion and a voice said, pleasantly, "Don't look round. What you can feel is a screw-driver with a razor edge, sharp enough that I can cut through your backbone with one little dig. So keep walking. That's it. Get in the back."

I opened the back door of the van and climbed in to where another member of the squad was waiting in the dark. I got a shove from behind and a hand from inside the van grabbed my neckband and hauled me in like a suit of clothes. Then he slammed me down on the floor, pressing my face against the metal rib of the van floor. The man behind climbed in after me, closing the door of the van behind him, and then kicked me lightly on the thigh. "We're here to tell you for the last time to fuck off, sonny," the man said. "Go away. This is not your scene." He pressed my face more firmly against the steel rib. "Understand?"

Another voice, West Indian, said, "Christ, here's the cops. Kill him, and let's get out of here."

In a detective story at this point you can look ahead and see that there's at least a third of the book left, and thus the hero must escape, but I had no such guarantee, and I was in terror of what was coming. I'm not used to pain, or the fear of it. I passed out.

~

I didn't stay unconscious long. When I came round, I turned on my back and added up my wounds. I could feel the tender spot

where I had been kicked in the thigh; the only other injuries were a bruised rib, probably from another kick after I passed out, and a banged-up eye from having my face pushed in the floor of the van. I was sore, but no worse than I would have been if I'd fallen out of a tree into a rock garden, say. The fact is, I had only been very lightly mugged, and I pondered the implications of that for a few minutes. Even if they had been disturbed by police it would have been just as easy to stave in a couple of ribs as to kick them lightly, and it would have been the work of a moment, surely, to stick a banana-knife up my ass. So these people weren't interested in hurting me. There probably weren't even any cops around. Mentioning the cops had been designed to frighten me with talk of killing; probably the muggers would have stunned me, then left me to figure out that I had had a lucky escape. When I passed out I saved them the trouble of having to figure out how hard to hit me, so that I would know I'd been assaulted. A tricky one for amateurs, because that's where my thinking led me. These people were tyros at the Grievous Bodily Harm business.

I drove home pondering my next move. I was determined to find Rosie, even after I heard the message on my voice mail. It was Helena, saying she had heard from Rosie. When I called her, Helena said, "Rosie says she's fine. Stop looking for her, she says. She is okay."

"Did she sound bad?" I asked.

"No. Maybe a bit tired. I think they probably have her tied up. She told me not to come to clean tomorrow."

"Did she know who I was?"

"Sure. She said to tell you to leave her alone."

"Okay, Helena. Thanks."

"You leave her alone now? You won't look any more?"

"No. I'm going to look some more."

"Good. Something's not right. Somebody's making trouble, lots of trouble."

"Yes. Somebody's making lots of trouble."

"You know who it is?"

"I'm going to try to find out."

~

At eleven the next morning I arrived at the college to give my opening lecture on *King Lear*. Richard and Alice Borden were drinking coffee in our office, waiting for me. They looked pleased with themselves.

"We just had our first meeting, informal, secret," Richard said. "The lawyers, theirs and Alice."

"How did it go?" I addressed myself to Alice.

"We waltzed each other round the table. Their guy said that the college thought we should allow the appeal to proceed, because if we did manage to forestall it, there would be a cloud over Richard's head. I said that cloud was already there because of the public nature of the process. He said, maybe, but he understood that our case was so strong that we would almost certainly win. I said almost was not enough, and if he thought the complaint had no merit, then why didn't the administration refuse to proceed. He said there was no place in the procedure for such an action, and I said, why not? He said he wasn't there when they put the procedure together. I said then it looked to me as if one had better be built in. Then he said that to conduct the hearing in secrecy would only fuel the flames of student resentment. Much better to do it in the open. Not for Richard, I said. So I think you've got what you want, Joe."

"Me? It's what Richard wants."

"The same thing," Richard said.

"What's that?"

"Deadlock. No, gridlock. No one can move an inch."

"What's next?"

"That's up to them," Alice said.

"Did you make it clear that if they did proceed with a charge of discrimination or whatever they call it, *in camera* or in public, based on race or colour, that you would represent Richard in that hearing, too?"

"Oh, sure, they know that. That's why it won't happpen. I'm earning my pay just sitting there, being black."

"And beautiful," Richard said.

There was a time, a few days ago, when I would have interpreted this remark as an attempt by Richard to make sure that Alice, even Alice, wasn't having her teeth put on edge by the continual references to colour, a standard attempt by a middle-class white, liberal male to aver his colour-blindness. And if that's what he intended, then he was going perhaps too far, because to aver that Alice was black and beautiful inevitably suggested that he meant beautiful *because* black, which is surely a subtle form of racism. I had long ago admitted to myself that Alice's blackness was an essential component of her beauty and therefore her attractiveness, to me, and I was prepared to live with whatever that said about me. But he had made similar remarks several times now, and because I was on the alert for them, I now saw that the tinge of fatuousness that had crept around his jawline did not arise from the crassness of his flattery but from the fact that he was struck with her.

Mixed feelings doesn't begin to describe my reaction to that. Insofar as Alice ever crept into my dreams, I accepted the fact that we had met at the wrong time and under the wrong circumstances, and that was that. But now, I realised, I was struck with feelings of jealousy, an urge to tell Richard to keep his fucking hands off. I picked up my books and turned to the door.

Alice walked with me to class to tell me the result of her enqui-
ries. "I've put the word out among all my clients," she said. "Some
of them would help if they could, I know that, but no one has
heard anything about two black men holding a white girl hostage,
not even anything remotely like that. And if they haven't heard, I
have doubts about the whole thing. You sure of your facts?"

"No," I said. "I'm not sure of anything. Thanks for the help,
though."

"Hey, hey," she said. "What did I do wrong? Don't we even get
to shake hands?" Then she said, "Richard?"

I blustered and shrugged and acted amazed and indifferent and
looked at my watch and asked what was she talking about, but she
said, "It is Richard, isn't it?"

"Are you seeing each other?" I asked, as lightly as a ton of
feathers.

She didn't reply at once, simply took my arm and walked me a
few paces down the corridor, away from the door of my classroom
where my students were continually bumping us to get by. She
said, "Is there something wrong with him?"

"Not that I know."

"Then what?"

Lately, under instruction from Carole, who wants a calm, hon-
est life, I have been practising voicing my little irritations, so that
they don't fester and poison the atmosphere. She does the same.
Now I said, "I'm jealous."

She stared at me amazed, both at what I was saying and that
she hadn't had to drag it out of me, dismayed, but, like any other
woman in those circumstances, pleased, too. Then she said,
"Thanks. That's nice. But first of all, you don't have to be jealous.
And second, I'll always be grateful to you for looking after me, but
you don't have to look after me any more. You don't have to

protect me from Richard. He'll always be Mr. Costril to me. But Joe, don't talk to him about me. Leave him alone. And now, leave me alone." But she kissed me again before heading down the stairs.

I walked into my classroom and began shouting about Act I, Scene iii of *King Lear*, almost before I had reached the podium. It took a good five minutes—Alice and I must have presented quite a spectacle in the hall—but eventually the students stopped looking at me and started to listen.

Afterwards I bought a tunafish on Wonderbread from the cafeteria and ate it at my desk while I made sure I would have something to say in the next two lectures in case I should be kept busy by Rosie, as I planned to be.

The man from Psychology put his head round the door. "Apotropaic?" he asked.

But I was ready for him, having peeked at his desk and noted the word underlined in a copy of the *London Review of Books*. "Designed to ward off evil," I said, without looking up. "Close the door after you."

~

Something had happened to pool and pool-halls in the fifteen years since I had last been inside one. I must have heard of the change, but the news had not sunk in, so that when I walked into Eggy's I was still half expecting to see Minnesota Fats holding court. What I did see was a lot of bond traders in arm-bands, an elegant bar staffed, not by a serf with a gimpy leg called Al, but by three young women in Laura Ashley dresses, actresses between engagements. Half a dozen tables were in decorous use, and at one of them Ulo Jensen was knocking the balls around with a man he introduced as Kevin Nugent. I was aware of the name because I saw his by-line every day; we shook hands and he pointed to his

cue. I shrugged. "Play the man a game," Ulo commanded, so I guessed it was a pre-condition of talking to Nugent.

The smart thing to do would have been a kind of reverse hustle, stroking him along so that the game depended on my last shot, which I would miss and leave him with a set-up. Unfortunately, I am not much good at pool; even as an undergraduate I played only three or four times, a kind of necessary ritual like the trip to the bordello over the border in North Dakota that was at the centre of one fraternity's initiation rites. (I never took that trip, either, because I was on a very tight budget that first year.) Since then there had only been the odd game with Berky. So I played as well as I could, stroking the ball very gently, managing to hit whatever I aimed at and move the balls about in a dignified fashion, thus creating the possibility that I had undertaken the shot with something in mind. Then one of those weird things, familiar surely to all beginners, happened. Nugent needed the black, I needed five more balls to get to the black, it was my shot, and suddenly my cue slid into a groove and I stroked four of them home like a surgeon. It was a four-ball fluke, of course, and the fifth shot practically missed the black but shaved it towards the pocket for a perfect set-up for Nugent. In other words, the result was exactly what I would have arranged if I could play the game.

Nugent shook his head, free now to admire my little run, and put his cue away.

I looked at Ulo for instruction.

"Let's sit down," Ulo said.

We moved to a quiet area at the end of the room, ordered drinks, and Nugent said, "I've heard about you, Joe. What can I do for you?"

I started in on a garbled account of what I was having trouble

finding out, ending with a request that he might give me some pointers on how to go about finding the information.

"What exactly do you want to know?" he asked, friendly, but in a cut-the-crap way.

"Is Goodfellow a crook?"

"Sure he is. Everybody knows that. If you mean, does he have a record? No."

"Does he take bribes?"

"Of course."

"Who from?"

"I don't have a list. But I would guess..." and he named three developers. "For a start," he added.

"How do you know?"

"They bribe everybody they can."

"Why don't they arrest Goodfellow?"

"Because they can't prove anything."

"Why don't you write about it?"

"Because he'd sue us. We need proof, too. It's hard to get."

"But you're sure."

"Oh, yes."

Laconic was the word. I wasn't certain whether there wasn't a certain amount of speaking for effect there, or if the subject had little interest for him.

"Why are you telling me?"

"You asked. Ulo here asked me to tell you. But this is just pool-table gossip. Right. It's true, though."

I said, "Does Ernie Hyde spend time with Goodfellow?"

"Who's Ernie Hyde? Never mind. The answer's probably no, if he's got Goodfellow on the payroll. If you want to know who Goodfellow hangs out with, go down to Oswald's Steak House, four nights out of seven. That's where he entertains."

"Who pays?"

"I thought you'd never ask. Goodfellow *always* picks up the cheque, even when he's eating with Oswald, the owner. One of the waiters is on *my* payroll. Goodfellow has an account there. And he's never done any favours for Oswald at City Hall. He's so clean, that's how I know he's crooked. Anyway, while he's demonstrating that he doesn't take favours, picks up his own cheque and everybody else's, he's also raising the question of how the hell he can pay those bills on a councillor's salary."

"What else can you tell me? What about Oswald? Is he...?" I wanted to say *clean*, but I was afraid my vocabulary was out of date. If I am to get into this business I've got to hang out with some people, pick up some crook talk.

Nugent said, "He's an entrepreneur. Built up a little empire, all on the up-and-up. Except, of course, that he probably gets half his booze cheap from the Mob, stuff like that. In other words, Oswald has long been suspected of being connected, but nothing has stuck. He owns Oswald's, the Chequers chain, four or five fake English pubs. He's got a restaurant for every purse."

"But Goodfellow's done him no favours."

"Not while I've been watching."

"Can't they get Goodfellow on his life style? His income tax?"

"You're thinking of Al Capone. See, Goodfellow's got a very prosperous wife. She runs an antique business in Yorkville, and she's very, very good, because she drives a BMW and spends a lot of time in Europe, and not in bed-and-breakfast places, either."

"But that could be a front. Maybe she isn't that good at the antique business, but she's laundering the money he gets in bribes...."

Nugent said to Ulo, "I see why you admire this guy. He's quick." He turned back to me. "That's right, Joe. That's what we

all figure. So now I've told you what everybody else knows, even the doorman down at City Hall, what else can I do for you?"

But I wasn't put down. Everybody knew that Goodfellow was crooked, but I was the only one who knew Hyde was. I just had to connect them.

Nugent laughed. "Look at this guy," he said to Ulo. "He thinks he's going to do what no man has ever done, get the goods on Goodfellow. Well, lotsa luck. In the meantime, care to play double or quits?"

"Sure," I said. All I needed was a run like the last one, plus one.

He kicked my ass all round the table; I managed to sink two before he finished the game. Before he left, he did me one more favour. He took a photo-copy of a newspaper article from his pocket. "I did one of these for all the leading candidates in the last municipal election," he said.

It was an article on Goodfellow, a history of his voting record, and a summary of his political philosophy, if that is the right word at the municipal level. A photograph acccompanied the article. "Thanks," I said. "My homework for tonight."

～

That night, in bed, Carole asked, "What has all this got to do with Rosie Dawn?"

"I don't know," I said, and added, to give it resonance, "yet."

Chapter Seventeen

THIS TIME I used my own van. I parked on Queen Street and went looking for the kid. The most logical place to start was the café where he had found me. The bartender would probably re-member me sitting in his window for three hours, and might just have noticed why I left.

"He works for a drug store mostly, delivering orders after school, on his bike. But he's all over, running errands for everyone. It works well. If you need something picked up in the neighbourhood, you phone the drug store and the kid picks it up. He's got about three other jobs, too. On what he earns he could

support his old mother, except she ain't so old and supports herself."

"Where does he live?"

"I told you, with his old mother. Actually she's about thirty-five, and good-looking. She's got a little dry-cleaning business, does alterations, you know. They live over the shop. You might find her there, but it's still daylight, so he'll be out hustling. She won't let him out after dark." He laughed. "She's afraid he might get picked up by some pervert." He laughed again. "Be like picking up a rattlesnake. That kid's been wise to perverts since he was about six. She's the only one who thinks he's innocent."

"I'll start at the dry-cleaning shop, then."

"Hold on." He picked up a phone from under the counter and dialled a number from a list taped on the mirror behind him. "Hi, Louis. Manny, here. Café Lisboa. Send the kid over, willya? One of my customers needs something fetched." He put the phone down. "Is he going to be glad to see you?"

"Why not?" I became aware now that he had never leaned over the counter, but had kept some distance between us, kept an eye on me.

"I don't know, mister. You sit in my window all afternoon; you don't belong around here; I've never seen you before that. Then Paco comes and takes you off. *He* knows you. Now you're back looking for Paco again. Will he be glad to see you? And listen, remember I'm watching. If Paco don't want to talk to you, he don't have to. Paco's mother is a friend of mine; I don't know you from hell."

Paco appeared at this point, standing in the doorway, wary.

Manny said, "Okay, Paco. Remember this gen'l'man? He wants to talk to you again. You don't have to, though. How's your ma?"

Paco said, "What do you want to know, mister? What happened to your eye?"

"I walked into a door. That place I asked you to take me to, I think it must have been the wrong address. The lady wasn't there. Who sent you to me?"

Paco shook his head. "Two men stopped me on the street, asked me to take you to the lady's apartment."

Manny said, "What! Listen, Paco, you know you don't run errands for strangers, guys who stop you on the street. Ever. People you don't know. Now tell this man what he wants to know, and get along home."

He was being very pompous, laying down rules for a kid who looked completely street-proofed to me. But his next words explained his attitude. "And tell your ma that I have to work tonight. I'll call her later."

The boy-friend. The substitute father, possibly.

Paco said, to me, "That's all I know."

We might have chatted a bit about the age, weight, height, and colour of the two men, in case Paco could add a detail from the perspective of the Artful Dodger, but now Manny came around the bar. "Okay, now. Home. I'm calling your ma in ten minutes to find out if you're there."

Paco said, "I'm working for the drug store until six and my ma expects me home at six-thirty. It's only three-thirty now. And you're not my baby-sitter. Shut your mouth." He turned and walked out, kicking closed the door behind him.

Manny turned nasty in his embarrassment. "And you. I don't want you going near that kid. There's something weird about you. I don't want the kid involved. Who is this woman? A whore? I'm not having Paco running messages for pimps."

I said, "She's my sister. I don't know who these two guys are,

but they know who I am, so they sent Paco with a message, but he got the address wrong." I stood up and put five dollars on the bar. "Thanks for all your help."

My final bit of sarcasm must have convinced him, because he reversed his atttitude immediately. "Okay. Sorry about that," he puffed. "Here, let me set you up." He waved a bottle of beer at me. "I try to look out for the kid, because I feel responsible. See, me and his ma…" He wigwagged his hand.

I accepted the apology, glad to be leaving on an agreeable note in case I had to come back. "I'll take a rain-check," I said. "Now I have to go."

I had seen Paco stop on his bike half a block down the street. He stood on the curb, watching the café window. As I came out of the café, he cycled away, very slowly, and I followed him to the end of the block where he turned south. When I got around the corner he was waiting for me.

I was ready to commiserate with him about his asshole of a protector, or about anything else we had in common, but with the directness of his age he said immediately, "I saw her go off in a cab when I came home from school for lunch on Monday."

"Why didn't you say?"

"They paid me to take you to them, not to tell you."

"I paid you, too, remember?"

He smirked. I doubted that it was an expression of cunning. It just seemed to him like a good joke two days before to do what I asked and get paid twice for it, knowing that she was already gone.

"You see the cab?"

"Sure."

"You know which cab company?"

"I know where the cab parks." He looked at me owlishly, and smirked again. I gave him five dollars.

"Who took her away?"

"Huh?"

"Who was with her?"

"The same two guys, but only one of them went with her in the cab."

"Black guy?"

"Nah."

"Neither one?"

"Nah."

I wondered if we were talking about the same group of people. I took the picture of Rosie out and showed him. "This lady, right? This is the one who took off in the cab."

"That's her. Great big tits."

"One day you'll think they're just the right size. And the guy with her. So he was white, okay. But big? Dark-haired? Fair? Bald? What kind of clothes? I need to know what to look for."

"Schwarzenegger," the kid said. "Arnie. He had big, big hands. I don't remember anything else."

"What did he talk like?" I racked my brains for some Hollywood convict-talk the kid might recognise. "Was he a tough guy? Gangster?"

"Nah. Like you," Paco said.

Suspicion grew. "Come down to my van with me. I want to show you a picture."

"I don't go in vans with old guys, mister."

"Good boy. Stay five feet away, but look at this picture I'll show you. Okay?"

I took a photo from the glove compartment, one of those I had taken the first time I had staked out Hyde's house on Steeple Chase Ride, when I spent the afternoon taking pictures.

"That's him," the kid said.

Jackson. The butler. Rosie had been kidnapped by the man who was supposed to be directing the search for her. According to Hyde, Rosie had been snatched only because she had stumbled on the man or men who were removing the tape from the recorder. So Jackson had the tape and he was blackmailing Hyde. My reaction was to consult my duty to Hyde. I could tell him, and it would be a fairly simple matter for him to hire a couple of friends to belabour Jackson with some two-inch dowelling until he told them where Rosie was. On the other hand, having cracked the case thus far, I had an urge to find Rosie and the tape myself, to present Hyde with a finished job as it were. And then, too, I was beginning to feel that it would be nice to be sure of my ground before I delivered Jackson and Rosie to Hyde. Jackson had almost certainly installed the tape recorder in the apartment without Rosie's knowledge, but Rosie just as certainly knew about the tape by now, and if Hyde were unhappy about that, then Rosie was vulnerable.

I became aware that I was not so much thinking through the possible meanings of Jackson's role in the affair, as I was facing again the skein of doubt I mentioned, the one that had been growing of its own accord as I chased after Jackson. In a nutshell, the real problem was still the difference between Helena's account of the phone calls and Hyde's.

The emergence of Jackson as the leader of the gang made it certain that Hyde was lying, that he would not be going to this trouble for a lewd tape, ingenious as the story he told me was. It was seeming clearer and clearer that the tape contained information that would interest more people than Hyde's wife. Once again, if I didn't find out a little more, I might be leaving Rosie at risk. When Hyde learned of how Jackson had conned him, he might arrange a little suicide pact involving Jackson and Rosie. I had no evidence to anchor this fancy, but my imagination had

been unleashed by the uncovering of Jackson and was now prob-
ably out of control.

"Okay, show me the cab," I said.

We walked back to Adelaide, across Spadina, and turned north.

"There," he said, pointing up the side street.

I let the kid go and walked over to the cab, letting myself in the
back seat. While I was getting settled I considered and rejected
half a dozen stories, and only used the seventh because I was out
of time.

"Where to?" He didn't look round.

I stared out past him to the street in front, making sure he
could see I wasn't looking at him. When he got restless, I said,
"Monday a cab with colours like yours knocked down an old man
on the crosswalk back there and drove off. We still don't know if
the old man will recover. I'm looking for the cab. The cops are,
too, but they don't know what I know. The colour of your cab, I
mean. I'll tell them if I have to, but I want to go all the way by
myself. Know what I mean?"

"Whaffor?"

"That old man is my grandfather. I'm going to leave that cab-
bie on the same crosswalk. Kind of a memorial."

"You got the wrong guy, buddy. Lotsa cabs look like this."

"You were here, though."

"When? What time was the old man hit?"

"Around twelve forty-five."

He lifted his clip-board off the dash and consulted Monday's
trip sheet. "Thank Christ," he said. "Look, see that line? See?
Twelve-fifteen, I picked up a fare by the apartment block back
there. Took them clear across the city. Half-hour trip, at least.
Then I picked up four in a row, cruising. I didn't get back here
until three."

"Anyone can write up a trip sheet. Anyone who knocked over an old man *would* write up a trip sheet."

"This one is real, mister."

"What was the address you went to? "

And then I blew it. Just as he was going to read it off he saw my face in the mirror looking like someone who's won a lottery, and my little scheme collapsed. He put the clip-board back on the dash, and said, "Fuck off out of this cab before I take you to the cops. Good try, though."

I got out of the cab and he watched me walk back to Queen Street where I was parked.

Chapter Eighteen

NOW I HAD a new way to get to Rosie, wherever she was staying. I drove across the city to Bayview, and then north to Steeple Chase Ride, where I found a call-box and dialled Hyde's number. Jackson answered. I breathed heavily into the receiver for a few seconds, then gasped, "Barley here. I've found where she is. I'm on my way there now. Tell her Hyde—shit, I'll call back." Mysterious but believable, I thought.

I crossed then to the street opposite the Bridle Path on the other side of Bayview, and put on my disguise. It was very simple. I remembered that Carole kept a headscarf in the glove compartment;

that and a pair of her sunglasses she kept in the van for driving west along the 401 at dusk. These had green plastic rims, and while rhinestones would have been better, the effect was still pretty good. The scarf and the glasses defined the wearer's sex without question. *Tootsie*. It occurred to me then that drag is the only disguise I haven't heard of bank robbers using, in life or in art.

I sat there for no more than five minutes before Jackson emerged and headed south on Bayview. I followed him at a distance, secure in my new disguise, down Bayview, along Davisville to Oriole Parkway, then south along the parkway and Avenue Road to Dupont, along Dupont to Bathurst, then south on Bathurst for a block. I watched him turn west at the first corner, but by the time I reached the corner his car had disappeared. I continued south on Bathurst, then turned right and right again, looking for his car. I found him quickly enough—he was still manoeuvring into a parking space outside a small white-painted house—and I stopped half a block away and watched him get out of the car and run up the steps of the house, say hello to a woman sweeping the steps of the house next door, and unlock his front door. Jackson was home. By now he would be looking after Rosie, whom he had probably left with the West Indian. They would be deciding what to do when I arrived.

So I had all the time in the world. I planned to park, call Hyde, and wait. I had just found a nice parking spot when Jackson came out of his house on the run, jumped in his car, and drove to Bathurst, where he turned north. Luckily the light at Dupont was red so I was able to tuck in behind him and follow him to St. Clair. This time we travelled west across the city into the Italian district on West St. Clair. Two blocks this side of the cemetery, Jackson turned north and I made the turn just in time to see him cut west at the first intersection, and then he turned south and stopped.

I parked outside the convenience store as he crossed the street, but by the time I was on my feet he had disappeared into one of several houses opposite. Rosie's place. I had moved like lightning to my next discovery, or assumption, that not only was Jackson trying to blackmail Hyde, but Rosie was, too. It made sense of my last problem, which was, how could whoever had installed the tape be sure that Rosie wouldn't stumble across it, and the answer had to be that Jackson had installed it in cahoots with Rosie. The whole caper was an elaborate set-up by Jackson, which depended on Jackson being in charge of both the plot and of Hyde's attempt to find Rosie without calling in the police. The only question left was, what was on the tape?

It was time now to call in Hyde, still the man who was paying me. There was a phone box outside the convenience store. "They're here," I said, when I was through to him. "You can come and get them."

"Who's 'they'?" he wanted to know.

"Rosie," I said, and paused, savouring the moment. "And Jackson. You've been double-crossed."

There was a long and (to me) satisfying pause. "Have I now?" he said almost to himself. "Have I now? By Jackson, you say? Jackson?"

"Yes," I said. I couldn't resist any further. "The butler did it."

"Ah? Yes, well, then, so that's the fookin' way of it, is it? Now then, what's the address?"

I told him the street and how to get there. "It's about halfway down. Number fifty. By the time you get here I'll have found the house. I'll be in my van, on the corner by the convenience store. I'll lead you to them."

"So you will. That'll be that, then." Hyde still seemed to be talking to himself. "Now I've got a couple of phone calls to make,

I don't want to come empty-handed, do I, and it might take me a
minute to organise myself. Could be an hour before I get there.
You stay put, all right? Unless they take off, then you follow them.
Otherwise, wait for us. You know my car? The green Mercedes?
Watch out for it, then. How many of them are there?"

"Two at least. Jackson and the West Indian. And Rosie."

"I'll bring lots of help."

~

I waited for half an hour. There was a tap at the window; two
boys of about ten with hockey sticks peered in at me. "Could you
park somewhere else, lady?" the bigger one asked, when I rolled
the window down. "You're in our goal place."

I looked around. There were five of them with sticks and their
own net and a ball. The rink they wanted to set up for street
hockey was the T-junction, which gave them a long playing area
end-stopped by the cross-street. I started the car and backed into
Nairn, across from the convenience store. The kids had given me
an idea. "Lady" they had called me, and "lady" I would be.

I addressed my next problem, which was how to reconcile my
Tootsie–upper half with my pants and oxfords. I rolled my pant-
legs up until I had two bare calves protruding from under my rain-
coat. It didn't look right, but when I let them down, I thought it
looked worse. I decided finally that a female religious canvasser
would be less remarkable in clumsy shoes and socks than in what
were evidently not her own trousers. I had never seen a funda-
mentalist in pants. I pulled the scarf close around my head, and
replaced the green sunglasses with my own horn-rims. My glasses
are strictly for reading so I couldn't see clearly ten feet away, but I
thought that a little peering would be in character. My street-guide
to Toronto, held against my bosom, stood in for a prayer book. I
set off down the street. Jackson knew me, but I was betting he

wouldn't recognise me under the headscarf and behind the glasses.

As well as finding the house, I wanted to get some idea of the size of Jackson's gang so I could warn Hyde when he arrived. Apart from Jackson there was the West Indian, and at least two other white guys, as reported by the storekeepers around Spadina and Adelaide, and by Paco. I wondered how many more there were. I climbed the steps of number 50 and rang the bell, moving across to the window immediately to peer in like someone who has been ringing for hours, but the light bounced off the window, making it opaque, and I moved back to the door and waited. A man came up the alley between the houses and nodded to me. Then the front door opened, finally, and the man who had come up the alley vaulted on to the porch and hustled me through the door.

~

There were only two of them—Jackson and another man—and Rosie. When the other man spoke, I realised that I had been expecting him to appear for some time, but he didn't look right. "Who are you looking for?" he asked. Before I could answer, I had to make sense of the fact that this whiter-than-me Tom Hanks–look-alike was speaking pure West Indian–Welsh.

"I'm from the Tabernacle," I said, waggling my street guide–prayer book at him. The fact that I got the line out at all showed the value of good preparation, but if I had had time for a proper rehearsal I might have tried for a contralto pitch. But I was responding automatically, in shock at the discovery that what I thought were two black West Indians had melted down into one pleasant-looking guy with a borrowed accent.

Jackson said, "Take the scarf off, Barley, and the glasses, and roll down the other pant-leg. The left one has already slipped. Then sit on the little chair with your hands on your head."

I did as I was told and waited for further orders. I was operating purely on instinct. On the one hand I was in a room with two kidnappers, who would have to kill me to prevent me from identifying them. On the other hand, these two had only lightly mugged me. Neither Jackson nor the Tom Hanks character seemed to have the air of people who killed other people to solve their problems.

I know what someone who is planning to kill you looks like. Once, in a beer parlour in northern Manitoba, a man sat down opposite me. He was big and had black hair growing out of most of his face. "Now," he said, "I'm going to kill you." He reached in his pocket, and just then the bartender, a man hired for his size, landed on top of him from behind, shouting, "Blackie, it ain't him. This guy lives here. He's a clerk at the depot."

I watched, immobilised with fear, as the bartender struggled with him, eventually holding him down. At the same time three friendly (to me) construction workers ringed me protectively, and two other patrons backed up the bartender. All the time the bartender was hollering deep into Blackie's ear that I wasn't the man he was looking for.

The volcano of Blackie's fury stopped erupting and he was allowed to stand up, two men draped over him like seaweed. "You better fucking not be," he said, and left.

"Stay home for a few days," the bartender said. "You look like someone he's been waiting for."

"What did this guy *do*?" I asked.

"Robbed Blackie. He came up on the night train on Sunday, travelling with someone who looks like you. Blackie fell asleep around Mile 70, and when he woke up the porter was shaking him because this is the end of the line. The next train is not until Thursday, so the guy is still in town and Blackie means to find him and kill him." It was a memorable misunderstanding.

But I couldn't see anyone in this room who looked like Blackie. I tried for a pleasantry. "You had us all fooled," I said to Tom Hanks.

"That so?" he said, coldly.

"You've got the accent perfectly."

"Maybe because that's the way I speak. I'm from Trinidad. That's how we speak."

"Now, now, John," Jackson said, warningly.

I had relaxed too soon. I had offended this man to the point where he now did look like someone who might hurt me.

"Sorry," I said. "No, I mean, really?"

"Really. It becomes a problem when I want an apartment in Toronto. Then I have to get some asshole like you to phone for me."

"Really?"

"Yes, really."

Then I was sick of it. This was no Blackie. This was someone with a wafer-thin skin whom I had quite unintentionally and inadvertently offended. He looked hostile, but still not like a fighting man and I thought we should get it cleared up now. "Go fuck yourself," I said, and got ready to pick up a chair to keep him off.

He laughed.

Jackson said, "Let's cut to the chase. What next?"

By now I could detect no threat at all. I said, "Are you okay, Miss Dawn?"

"Do I look as though someone's been beating me up?"

"No, you don't."

"I'm fine."

"What are you going to do now?" I asked Jackson. I meant, now that I had caught him, and given that he had no plans to kill me. The fact that Rosie was unharmed was further proof that

these guys were essentially benign, just looking for a little easy money. Their little scheme had just got out of hand.

"It's what *you're* going to do that I'm concerned about."

I was in a very awkward situation, more difficult socially than criminally. I just didn't feel like telling them that I had—it was starting to feel like—*betrayed* them, without some preparation. I said, "You know what I have to do," avoiding the fact that I'd already done it. "But there are a couple of things I'd like to know before I do it."

"Why do you have to do it? You don't have to work for Hyde."

I pretended to get angry. "It's kidnapping," I said. "Abduction, call it what you like. You've held her prisoner for two weeks." I cast around for a way of avoiding clichés, and failed. "This has got to stop," I commanded. "You must release her." Helena-talk again.

Before Jackson said a word I got a dozen replies from his body: a smile, a leaning back, a leg cast across the arm of a chair, a look over his shoulder at Rosie, a look over the other shoulder at Tom Hanks, all adding up to the fact that these three were in partnership. He said, "Rosie Dawn, I release thee," and waved his hand in a fake magic sign. She giggled and Hanks grinned.

Jackson said, "See?"

So I was right. They were all in it. Blackmailing Hyde.

"Wanna come in? There's still time." He took a tape from his pocket. "We figure it's worth a quarter of a million. You can have fifty thousand. It's Hyde's money. Everybody's entitled to it."

"Let me get this straight. You and Rosie cooked up a scheme to blackmail Hyde, right? But why did you have to pretend to kidnap Rosie?"

"That was Rosie's idea. See, she found the tape and we worked from there. First, we thought we could con Hyde into believing she knew nothing about it, that she wasn't there when we broke in

and took the tape. But when we were working it out she got con-cerned that Hyde would trip her up."

"I've never been able to lie worth a damn, except about my age and my weight," Rosie said.

"So we figured we'd kidnap Rosie as part of the plan, then Hyde wouldn't go behind it. It was supposed to sound like us stumbling. The story for Hyde is that we were robbing the apart-ment and found the tape while she was out, but she came back while we were still there so we had to take her with us."

"It didn't work," I said.

"Sure it did. Hyde doesn't know anything about Rosie's con-nection. We could 'let her go' now and she'd be okay, as long as she keeps away from being questioned by Hyde. If the cops were involved, it would be different, she'd break down right away, but they're not and Hyde won't bring them in."

"Because of what's on the tape?"

"How did you know?"

I turned to Rosie. "Hyde hardly ever called you when Helena was there. When the phone did ring, you never answered. You could have said you were busy, that Helena was there. But you just let it ring."

"Ernie told me never to answer it."

"That's what I figured. The phone was installed so Hyde could talk to his pals without worrying about being bugged. These days, everybody's bugged. Whatever is on the tape may be exciting, but it isn't sexy."

Jackson interrupted. "I'm a little behind here. Why didn't it work? Snatching Rosie, I mean."

"Watch your language," Rosie said, giggling.

"You're too soft-hearted, or not good enough actors," I said. "Those pictures you gave me of Rosie…"

"In the deerslayer hat," Rosie said, still giggling. "That thing had *fleas.*"

"I'll fumigate it before Halloween. Anyway, what I mean, Rosie, is you should have roughed yourself up a little. You looked like someone horsing around at an Ice Carnival or something. Hyde noticed that. He was surprised that someone abducted and held captive by a gang of kidnappers should look so unharmed. He couldn't figure it out, but he would have, later. He still wouldn't have said anything to you guys until he was sure. He probably planned to take it out on Rosie. See, if you'd released Rosie, according to the script, Hyde could have pounded her and blamed it on the kidnappers. She wouldn't have been able to say a word."

"Jesus," Rosie said.

We all paused for thought. "By the way, who are *you*?" I asked Tom Hanks.

"Belper," he said. "John Belper." He put out his hand and I shook it, thus confirming that in the last few minutes I had switched sides. "I'm Rosie's classmate," he said. "I came along for the ride. All I was supposed to do was make a couple of phone calls and make like a Trinidadian gang. I stayed around to look after Rosie when it got complicated."

"He helps me with my essays, too," Rosie said.

"He's your boy-friend?"

"No. *Billy's* my boy-friend." She pointed to Jackson.

Jackson said, "I'm not a professional kidnapper. This thing just escalated."

"What are you, professionally?"

"Right now I'm out of work, I think. I was in veterinary school until I ran out of money."

"Then you became a bouncer?"

"I've been a doorman after school since grade twelve, but it doesn't pay enough. So I went to work for Hyde, to get a stake to take me back to school. He wanted a goon who could read and write and who could wear a tie. A butler, he called it. So there it is. Now what?"

Chapter Nineteen

I looked at my watch. We had been there for half an hour. It was time to go. I said, "Now that we've got all that cleaned up, I have to tell you, Hyde is on his way here. Half an hour ago I was working for him and I called and gave him this address. He said to expect him in an hour. I'm to watch the house until then."

"How did you find us?" Rosie asked.

I told them how I'd baited Jackson and followed him after I'd been unsuccessful with the cab-driver.

Jackson looked pleased. "I had a feeling someone might be tracking us Monday. I paid the driver to keep quiet. Still, what you

did then was cute. But now what do we do? Get the hell out of
here, I suppose. Where do we go? Your place?"

"We'll have to delay them for a while, maybe for good," I said.
"Try this. Rosie, find us a sheet of paper and a felt pen." When
she brought them, I wrote, in thick black letters, BACK
IN FIFTEEN MINUTES. GONE FOR GROCERIES. GO ON IN. IT'S UN-
LOCKED. I explained the scheme to the others.

We left the house and the others took cover in my car. Hyde
knew Jackson's car, so we planned to leave it on the street, showing
that Jackson was still around. I took up my post outside the phone
box. Twenty minutes later, Hyde appeared with four others, one
of them a regular-looking, if fat, citizen I recognised, and three
who looked like goons. Four of them approached the door while
one of the goons sauntered across the street to keep an eye on
their backs. Hyde read the notice, nodded, and all four disap-
peared inside.

I dialled 911 and asked for the police. When I got through I
went into my knife-grinder accent. "Dey's a bunch of burglars
broke into da house," I said, in a very husky whisper. "Number
fifty, Nairn Avenue. Dey are dere now. I'm a neighbour. I bin
a-watching dem. Dere's t'ree of dem carrying guns. What? You
t'ink I don't know when a man is carrying a gun? Now!"

I came out of the box and crossed the street. Jackson had the
engine running, and I got in and we waited.

They were quick. In five minutes, four cars appeared, no sirens,
nothing, and eight cops quietly surged towards the house. Two of
them went round the back. One of the others took a look through
the front window. (Later we learned that what he saw was Hyde
and his goons tearing the place apart, looking for the tape.) Mean-
while, Hyde's lookout man sidled off down the street and made it
to his car, but the police had both ends of the street plugged, so all

he could do was sit there, looking like a citizen afraid of missing an appointment, which if he had done, might have worked, but he panicked, got out of the car and started to run, and one of the cops opened his car door sharply as he ran by, and then collared the remains.

In a very few minutes the whole gang emerged, Hyde and his pals in handcuffs, the cops looking at each other in glee and surprise. One of the cops was carrying two plastic grocery bags and we watched his colleague drop in the last gun as they came down the path. We walked down to St. Clair for a cappuccino.

~

"Here's where I say: 'I guess we owe you an explanation,'" Jackson said to me, when we had our cappuccinos in front of us. "Why don't you ask me what you haven't figured out yet?"

"First," I said, "what's on the tape? Not Rosie talking dirty. That much I know."

"I'm a dancer," Rosie said. "I don't talk dirty."

I said, "You are Ernie Hyde's—er—mistress?"

"No way."

"But Rosie..."

"Could we use my name, please? It's Lynn. Rosie's my professional name. You know where I got it?"

I bit my lip and shook my head. "Tell me."

"From this poem. The *Odyssey*. I'm studying it. I don't want to end up lap-dancing when I'm fifty."

"What do you want to do?"

Now she looked shy. "I want to be a writer," she said. "One of my...clients...said you can't write unless you've read a lot, and not just trash, either, so I enrolled in this course which is supposed to make you ready to go to university. It's terrific."

"How far have you got?"

"Two weeks ago we'd just done the end of the *Odyssey*, the scene where Telemachus hangs all the handmaidens for screwing Penelope's suitors, as if it's *their* fault. Jesus. Nothing changes. I reckon Homer would have had me thrown over the cliff if ever he saw me up at the Iron Ore House. Apart from that bit, I thought it was a great story."

"What do you want to write?"

Now she looked really shy. "I read about this girl winning prizes by writing stories about the johns she knows. You know, a hooker. I'm not a hooker, but I know some stories I could tell. I'll start there. You think that's a good idea?"

"Write about what you know, they say. I guess so. But why did you say, 'No way'? I've seen the pictures. I even have a couple."

"You kinky, too?"

"I got the pictures from Hyde so I could identify you. I showed them around to see if anyone else recognised you."

"You did what? Those aren't pictures of me, for God's sake. They're pictures of my *twat*. That's how Hyde got his jollies. He took pictures. That's all. I used to go to the apartment about once a week, so he could take a new bunch. You showed them around? Jesus."

I explained how I had manufactured some perfectly innocuous pictures by cutting out her face and attaching it to a respectable body.

"The pictures with my face cut out must have looked kind of funny. What did you do with them?"

"I threw them away.… Oh, dear. Oh, God."

"What's the matter?" Jackson said. "You left them somewhere?"

"Something like that." I made a gigantic effort to concentrate on the matter at hand, reserving until later consideration of how to deal with Carole. "If it's not you on the tape, who is it?"

Jackson said, "A couple of people. One is a stockbroker named Brant. The other is Councillor Goodfellow."

"One of the guys we just saw. Let's start with him. Why is his voice on the tape?"

"Did you find out?" Belper asked him.

"Not entirely. I don't think it matters." Jackson turned to me. "Councillor Goodfellow is on a building committee at City Hall. Ernie Hyde has some interests in real estate. Specifically he wants to turn an old sugar warehouse into condominiums, very cheap ones. But he doesn't want to meet all the standards. Goodfellow is the man to get him special exemptions, stuff like that. A lot of plans Ernie has will need Goodfellow."

"So he's bribing Goodfellow. That on the tape?"

"Not with cash. With food. See, Goodfellow gets money from a guy named Oswald who owns some restaurants, including the Chequers chain."

"Why are they called Chequers?"

"I wondered about that. You know how I found out? I tried to think what name I would give to four coffee shops that sold soup, and sandwiches, and microwaved stuff. I couldn't come up with one. So I started to look up the chains that already exist. A lot of them have names that are nothing to do with food, Swiss Chalet, Salisbury House, stuff like that. That's when I realised that to get people to remember you, you are better off finding a name with good associations, never mind about *dunkin* or *yummy* or stuff like that. So that's what they did, I figure, and came up with the name Chequers. Everyone's heard of it from someplace, though they can't remember where from, but they think it's got to do with something classy."

"Nixon's dog? That's classy?"

Jackson looked thoughtful. "I'm not sure they knew about

Nixon's dog. Goodfellow's from the U.K. originally. He would have called the chain Chequers because..."

Rosie cut him off. "Then what?"

"So if you have a look at the records of Lunch Box Ltd., which Hyde owns, you'll find there's an awful lot of condemned food been written off lately, as if the refrigerators keep breaking down. But nothing went bad; it went to one of the Chequers restaurants. It's very neat. There's no money showing. At the same time, the drivers don't have to be in on it—they use regular bills, and the managers of the restaurants send the bills to the head office to be paid. Head office files them. So Ernie Hyde supplies Oswald with free food, Oswald pays Goodfellow, and Goodfellow uses his influence to get Hyde his permit. At the same time, Ernie, never one to miss a trick, is also claiming the cost of the spoiled food, or some of it, as a business expense. As I say, neat?"

I said, "So they *could* get him on his taxes! Like Capone."

"What?"

"Nothing. So why all the hooha about the phone in the company apartment?"

"There's no reason for that at all. Hyde told Goodfellow not to call his house because he wanted to avoid being tapped if there was any kind of suspicion. For the same reason, Goodfellow didn't want to be seen with Hyde in public. They were both too smart to get caught for the usual nonsense of Hyde signing Goodfellow's expenses on a Florida trip. But they didn't need Rosie's phone. Hyde could have made sure his own was secure."

"But he couldn't be sure *you* weren't listening, right?" I laughed. "Or his wife and daughter, I guess. I figured out a while ago that Hyde was using that phone to talk to someone other than Rosie. So Hyde was using the apartment to take dirty pictures and to get phone calls he didn't want anyone to overhear. He didn't reckon

on you lot, though, did he?" I looked around the table. "I've just remembered something you said." I turned to Jackson. "You said Rosie *found* the tape. You didn't install it. So who was bugging Hyde?"

They looked at each other. Jackson said, "Hyde. He put the machine in to tape the calls from Goodfellow and this stockbroker, Brant. Maybe he got the idea from Nixon, too."

"Why?"

"Hyde wanted a record of the deals. For the books, the real books, and to blackmail Goodfellow with if their arrangement ever went screwy. That's what you just saw going down. After you called Hyde, Hyde called Goodfellow, told him about the tape and where it is now. The guy with the moustache. That was Goodfellow."

"I know. And the other three?"

"Bodyguards."

"Were they going to kill me? Us?"

"I think they were going to do whatever they had to to get back the tape. The guns were in case."

"And the stockbroker?"

"I don't know who he is. But I can tell you what he's doing. He's currently arranging through a crooked stock dealer to sell short the Lunch Box company through some outfit he's got set up in the English Channel Islands. I don't understand how it works, but Hyde's stock is way up at the moment, much higher than it's worth, and whoever takes him over will find out that the company is worth a lot less than they thought."

"Why doesn't Hyde sell his own company short?"

"I think that's illegal. Some of the things on the business page must be, surely."

Chapter Twenty

WE SAT there savouring the moment. I said, "We have to cel-
ebrate." I called the waiter. "Four glasses of your best grappa, my
man," like a character in Trollope, hoping that it wouldn't sound
snotty to an Italian waiter. I looked around the table and a mild
fear struck me that, denizen of the Via Italia though the waiter
might be, perhaps he, too, was a student—everybody else seemed
to be—and would be sufficiently well-read to take offence, but he
just smiled and went off to get the drinks. The grappa I have
drunk before is a little rough, but I figured that if there are grades
of it, then "the best" would be drinkable to a Jameson man. When

he brought the drinks, and the bill, I saw what he had been smiling at. "Forty-four *dollars*?"

He said, "The best grappa in the liquor store is seventy dollars a bottle. This is better. We bring it in ourselves. Eleven dollars a glass is cheap. How does it taste?"

I tasted. We all tasted. Rosie asked, "Is it worth it?"

"Don't you think so?"

"This is man's stuff, this bullshit about wine. Is it? Worth it?"

We tasted again. "Yes," Jackson said.

"Are we finished?" Belper asked. "That why we're celebrating?"

"It all looks wrapped up to me," I said.

Belper shook his head. "By the time they get to the station, Hyde will have a story about his life being threatened while he was consulting with Councillor Goodfellow about building regulations. Hyde will say he asked a couple of friends to go to the house with him to meet this fellow who was threatening him. By now, it'll be us and Rosie trying to blackmail him about his relationship with her, a blackmail which he never submitted to. So when he got there he found he was tricked, as the police were, by his blackmailers, and he'll have two lawyers to back him up. He'll be out on bail any minute, and looking for us before dinner, with four more goons."

"But they'll prove it eventually."

"Eventually might be too late for us," Jackson said.

Belper said, "What we need is a dozen copies of that tape."

"I still haven't heard it," I said.

"That can wait," Jackson said. "We need a sound equipment shop. Let's go get the tape."

"Let's make a phone call first," Belper said.

"To whom?"

"The cops. Tell them to expect the tape, and on no account to

release Hyde and Goodfellow until they've listened to it." He left the café to make the call and to find a cab. When he came back he said, "That's one. Now where do the others go?"

"The head of the Fraud Squad?"

"The head of the Stock Exchange?"

"The mayor?"

"The attorney-general?"

We agreed on all these, plus a media exclusive to Nugent. Next we worked out a story for the cops. Much depended on what Hyde was telling the police at that moment. We had to keep it simple, and in the end the story went like this:

Rosie had found the tape when she was dusting one day, played it back, got frightened and decided to have no more to do with Hyde. (The tape contained hints of what Hyde would do to people who got in his way.) Thus she had run away. Jackson had tried to find her for Hyde, and Helena had recruited me to look, too. Jackson had found her, was touched by her story, and decided to help her. I had found Jackson and decided to help him to help Rosie. (There would be no mention of Belper.) The rest of the story fell into place. I would, in the story, put in a call to police, which trapped Hyde and Goodfellow. We baited the trap with Hyde's own tape.

We drove round to pick up Jackson's car and found them waiting for us, two goons leaning on Jackson's car, and Hyde and Goodfellow sitting in their own car waiting for the goons to deliver our carcasses. It was only the one-way street system that had caused me to come up behind them without being seen, giving us just enough warning to send us scuttling back round the corner to my car.

"Let's get out of here," Jackson said. "Quick."

"The tape is in the house," Rosie reminded him.

"So let's phone the cops, tell them where you put it. You phone them, John. Do your Belafonte bit."

Rosie said, "You mean we aren't going to get anything out of this?"

That's when we should have said, no, we're going to get out of here. But Jackson got an idea. "We can still get that tape," he said.

"There's two linebackers watching the house," Belper reminded him.

Jackson said, "But they don't know who for, do they? I need one minute." He turned to us. "Hyde knows me and Rosie, but he doesn't know you."

I could smell where he was going. "I've spent hours in the man's living room and his den or whatever he calls it. Of course he knows me."

"Not in that outfit. Rosie, lend him your lipstick."

While this was sinking in, he added, "He doesn't know you, either, John."

"He knows what I sound like."

"That's right, so he'll be looking for someone who looks like you sound, right? What you guys have to do is make Hyde and Goodfellow watch you, while I do the tricky bit." He explained his scheme.

I hardly listened. The mock mugging these two had subjected me to had sharpened my appreciation of the real thing. The goons would be serious. They probably really had banana-knives. "It's a little nerve-racking," I said. "We're probably going to have to do the rest of the houses on that side of the street, with Hyde watching. No."

"Six," Jackson offered. "Six will be enough. Then cross over, come down the alley. It's a doddle. Rosie will wait for you with the engine running. I'm doing the dangerous bit."

In the end he persuaded us. Jackson disappeared to work his
way to the back of the house, and Belper and I prepared ourselves
for our act. We crossed the street when we were ready, very aware
of the goons watching every shadow. We knocked on the door of
the house four north of number 50 and Belper went into his rou-
tine. We had agreed he would do the talking because I wanted to
keep as far away from being gazed at directly as possible. Scarf,
sunglasses, and lipstick did not constitute an impenetrable dis-
guise, and anyway, for what we were doing the details were wrong.
We were relying on the probably Italian householders' limited ex-
perience of evangelists. Belper was good. The door opened and he
said, "We are calling for Jesus, sir. Say the word and you can be
saved. Are you saved? Does Jesus know your name?"

The ninety-year-old retired terrazzo-layer from the Abruzzi
said nothing. Belper repeated his message. Slowly the old man
closed the door, still silent. That suited us. We moved on. Next door
there was no reply. We knocked and rang until the tile-layer reap-
peared in his doorway, shaking his head and making gestures as if
wiping us off his hand. We moved on, knocked on the next door,
and then we saw Jackson down the side of the house, as he disap-
peared into the back of number 50. We waited to give him his
minute, and moved on down the street, making the four more calls
that Jackson had planned, getting no answer from two of them and
hostility from the other two. Evangelising is an unrewarding life.

We crossed the street, and for the goons' benefit, made a panto-
mime of seeming to decide what to do next, finally going down the
alley, and then making a run for my car. Jackson and Rosie were
already crouched down in the back when Belper and I climbed in,
and then, just as we were getting out of there, the goons appeared,
running from behind us, nearly reaching us before I could take off.
I headed for St. Clair, watching the goons reach Hyde's car, and

then the car move out after us, and now we were cutting to the chase.

Hyde's car was superior to mine in every way so I had to stay in heavy traffic to keep them at bay until I could think of a manoeuvre to get rid of them. Towards the west, past the old stock yards, St. Clair loses its street-cars and becomes empty enough to allow a proper pursuit, so I turned the other way and concentrated on the single trick of trying to get past street-cars, timing it so that no one could follow. I never quite managed it: they stuck to us all the way to Bathurst and beyond, and I turned south on Russell Hill Road thinking I might risk not stopping at the sign half-way down, but they stayed with us all the way down. Jackson said, "You don't *have* to use your turn signals, you know."

I rocketed—it's the only word—across to Davenport and then we were travelling south on Bay Street, both of us in the illegal lane for cabs only. I figured if the cops stopped us it would be preferable to the goons, but we could have had Lady Godiva on the roof and no one would have cared.

At the foot of Bay Street I stopped the car and we made a run for the lake. The next scene should have taken place on the Island Ferry as I dropped the tape over the side just before they rushed us from the other end of the boat, but they caught up to us as we reached the fence around the dock. Then it was us four leaning on the fence, nearly vomiting from the exertion, and a goon at each end of the fence, also heaving and cursing, waiting for Hyde to catch up and tell them what to do. Hyde and Goodfellow arrived at last, looking worse than any of us, in no mood to worry about the spectators. When he had some breath, Hyde said, "Give me the fooking tape. Now!"

I said, "I'll do better than that, Ernie," and flung the tape out into the lake. The others, Rosie, Jackson, and Belper, stared at me.

Hyde said, "Throw the fooker in the lake after it."

Lake Ontario is very cold in the fall, but it is surely only three feet deep where we were, and I felt for a moment like Br'er Rabbit being threatened with the brier patch. The same thought occurred to Hyde. "Break his legs first," he ordered.

Councillor Goodfellow started to back away, gibbering with fright as he realised the league he had drifted into. The goons closed in on me, and to give them their due, Jackson and Belper tried to get in their way as Rosie took a deep breath and let out the most fantastic scream I've ever heard.

None of this seriously impeded the goons. Big as Jackson was, one of the thugs simply threw him at Belper, as the other goon advanced on a steadily screaming Rosie. But it gained the few minutes we needed, and before the goons could continue with their work we were deluged with noise and light as half a dozen squad cars disgorged a dozen armed cops and two plain-clothes men. The goons stopped dead, and, old hands that they were, waited for the cops to handcuff them. Hyde and Goodfellow tried for a bit of "What's going on?" but one of the plain-clothes men cuffed them, banging Hyde accidentally across the mouth with the handcuffs as he chained them together, and shoved them into a squad car. When the villains had been carted off, the two detectives told us to follow them.

∼

In the car, Jackson said, "And where did *that* tape come from?"

"It was a spare I found in the apartment. A blank. I figured you'd left it behind."

"You figured *I'd* left it?" He took the real tape out of his pocket, and kissed it. "Let's get those babies fixed up. I still think…"

"No way," Belper said. "We're not dealing with strangers any more and nor are they. Let's get it copied and write our memoirs."

~

We followed the cops back to College Street where the two detectives joined us in an office. The senior of the two men—who said his name was Sergeant Chestnut; his buddy was Sergeant Grimaldi—explained that they had known about us from the start. They had been on to the Hyde/Goodfellow scam for some months, and more recently to Hyde's stock-swindling scheme. Until now, though, they had lacked hard evidence. Somehow they had missed guessing that Hyde would have used his love-nest to receive messages, so they never bugged it themselves. "Anyway," Grimaldi said piously, "that would have been illegal."

I said to Chestnut, "Bend sideways as if you're reading something."

It took him a minute to understand, and a few more minutes to agree to bend, but when he did I could say, "You're him. The guy watching Hyde's house."

"That's right. We were watching Goodfellow, too. And you, lately. We knew what was going on, but we didn't know about the tape. Now we do." He said it was only when I got into the act that they began to hear about a tape, and they had been following me, Jackson, Hyde, and Goodfellow ever since. They thanked us.

Then Chestnut said to me, slowly and as if he and I were alone in the room so I would know that he was up to something, "You know what I think? I think Rosie here and Jackson were shaking Hyde down, or trying to. They were pals, did you know? Jackson was the bouncer up at the Iron Ore House before he went to work for Hyde. I think Jackson here put in the tape recorder for Hyde, who knows fuck-all about electronics, and then cooked up this fake kidnap. Then you stumbled along and Jackson had to choose, you or Hyde. The whole thing was getting out of hand. All these two had planned was a little scheme to get maybe a hundred grand

out of Hyde, but Hyde would have killed him to get the tape. So would Goodfellow. Maybe the stockbroker, Brant, would, too. Maybe not. Anyway, that's what I think. But if I say so, Hyde's lawyers might pick up a bit of sympathy in court. You keep saying *blackmail*, see, and the jury gets antsy. They don't like that word. And they don't like double-crossers, either. That's Jackson, here. *And* Rosie. After all, you pay a girl a fair price for a piece of ass, or even a picture of one, and it's kind of unethical for her to take your money, then try blackmailing you. Nice whores don't do stuff like that. I mean, if they did, none of us would be safe, would we? You see my point? It could get messy."

"I'm a student," Rosie said from where she was standing by the window. "Not a whore. What I do is to raise the money for my fees. I'm not eligible for a student loan, they said. Okay?"

Chestnut smiled at her, then continued. "Right now we've got a nice little corruption charge against the two of them, and the stock exchange boys are in touch and deciding what charges to lay themselves. They've delisted his shares already. So Hyde will be broke as soon as this comes out, broke and in jail. That's our case. We're not going to dirty it with talk of breaking-and-entering and hired guns and all that shit. Hyde will keep his mouth shut or risk ten more years. We'll have a nice little case based on information received, information which, when we checked, turned out to be accurate."

"The information being the tape?" I asked.

He nodded.

"But you started long before this tape came out. Where did you *really* get your information?"

Chestnut looked at Grimaldi, who shook his head in warning, but Chestnut liked having the floor and he thought of a way of keeping it. "Fact is," he said, "life for us would be a lot harder if

we didn't sometimes get the cooperation of the public, as we did in this case. Somebody told us."

"Who?"

Again Grimaldi didn't want him to continue, but again Chestnut was enjoying his part too much to get off stage without a last word. "Let's call him Jekyll," he said. "Solve that one. Let's go now."

But I didn't have to solve it. I knew who it was. Torgol, the guy in Hyde's office, the first person I talked to after the receptionist.

~

They tried Richard two days later. They didn't call it a trial, of course. That was Richard's word. Officially it was another private, informal get-together in the dean's office to decide whether to hear a complaint from an Ethiopian student in respect to the behaviour of his instructor, Richard Costril.

The meeting took two hours. First they read the student's complaint, then a letter of support from a student who had failed the course seven years before, dropping out because Richard had poisoned the atmosphere in the room with racist and sexist remarks. Alice asked that the meeting be adjourned while that student's records were found, and the wizards on the administration computers found the record in five minutes, or rather they found that no such student had ever existed, and that Richard had not been teaching the course at that time anyway. The dean then suggested that they were all wasting their time and they should end the meeting forthwith. In Richard's favour. He was aware that he was being arbitrary, the dean said, but sometimes he felt it was necessary to be arbitrary. He tried to look like a man who was prepared to stake his job on the issue.

Alice said, fine, but in case anything should flow from today's session, she wanted to take advantage of it to acquaint the group

with what she had assembled so far. Without prejudice. Alice then spent a pleasant hour listing and describing the witnesses for the defence, thirty of them. First, in a bloc, seven students of colour, black and yellow, from Richard's current classes who would testify that apart from a hint of anti-French sentiment (the European French, not our Quebec neighbours: Richard claims to have been swindled in Paris more often than in any other capital in Europe) Richard was as free from racism as you could hope for from someone of his background. Then two Jamaican students would testify that the Ethiopian had tried to bribe them into supporting him. Next Alice would call on some of Richard's colleagues, his chairman, and the registrar, to testify that Richard's relationships with his students were excellent, and I would be called to testify that even behind the closed door of our office, Richard never uttered racist slurs. (I thought the jokes didn't count.)

I felt sorry for the dean, but he set it up, not having had the guts to deal firmly with it in the beginning ("by kicking the Abyssinian's arse," a member of the history department suggested) and Alice made him eat it, all in preparation for the next round if this thing should go public, the sueing of Hambleton College, and of the dean, and our colleagues, and everyone else Alice could name.

The result of the committee's deliberations was announced ten minutes after the hearing ended. Richard, of course, was absolved, and an apology promised. The Ethiopian said the committee had been biased from the start, and planned to appeal, this time to the law.

~

Carole's sexual shenanigans came next. This time her experiment involved no actual perforation of my derma. We were in bed and soon we would make love, I hoped. We don't have a problem reading each other's signals.

Carole reached over and scratched me, lightly, to let me know that what I had in mind was fine by her. She said, "Do you really like me—us—as I am, we are?"

I said, "What I like about you would take time to describe, because different bits of you are at their best at different times. Ups-a-daisy. Starting with that soft area behind your knees—the left is softer than the right—that's at its best after you've been outside, reading in the garden. 'Sun-kissed' is the phrase I am trying to avoid. How's that for a start? Your bottom? Your bottom is prime just after a too-hot bath subsequent to a day of cross-country ski-ing— pink and misted. The inside of your thighs, now, are nothing much to look at, but the *feel* of them gets them a place in my catalogue. As for your belly, it's not like a heap of wheat at all; it's like a soft, lightly downed belly that ought to be reserved strictly for post-coital grazing. Your breasts, on the other hand—am I making my point?"

She said, "I thought maybe you might still want to experiment a little?"

"In what way?"

"*I* don't know. People enjoy all kinds of odd things together, Arlette says."

I organised myself for a speech. It's nice when you know what's going on but they don't know you know. You are relaxed. You can rehearse your lines, waiting for your cue.

"Not interested," I said. "I have listened to myself carefully and heard no fantastic echo from the depths of the kind your brother-in-law has told me about; that is, if you don't count my relatively recent, occasional tendency to shout, 'Here we go; hold on to your hat' during the last few moments of congress, a harmless enough eccentricity—not a perversion—which I only indulge in with your permission when you have decided that we are tonight having one for Joe, a kindness-to-Joe night.

"I'll stop it if you like; my point was ever that sex did not have to be solemn in order to be serious. As you know, I enjoy all of what that novelist we saw on television called the sticky parts of your body, and I welcome your interest in mine. But the dryer and sharper bits of you I don't want, along with knives, chains, whips, Brillo pads, and nutmeg graters. Or any other of that lot. Now what the bloody hell is this all about?"

I knew, of course, but at this point I felt I could act out the kind of surprise that would improve our relationship, whereas a genuine discovery might have been fraught with the wrong kinds of emotion.

She went to her bureau and returned with the shards of the photos. "What's *this* all about?" she asked, holding one up and poking her finger through the hole.

As I say, had I not known already, I might have been upset by the implications of what Carole was suggesting, but I laughed warmly, shook my head, went to my closet in the other room, and came back with the pictures I had created. When she had studied them, she giggled. "Oh, dear," was all she said.

"You could have asked," I said, taking her hand.

"I wanted to, but Berky said you would say you'd found them or something. He said I must accept you as you were and try to find a mutuality of taste. That's what I've been trying to do, but I don't have any funny tastes to share. As the lady said about folksongs, you can have your *tra-la-la*, but give me a good old-fashioned lay."

"Berky spent the whole evening while you were at the art gallery trying to find out by himself."

"He was only being helpful."

"Dirty swine. Okay. Let's tell him…let's see, that I found them in a mail-box at the college. Not mechanical aids at all, but they

are pictures of one of my students. The face is cut out as a kind of teaser, because the first picture was accompanied with a 'Guess who?' note. Since then I've been getting a picture every week. Let's tell him, let's see, that when Richard was accused of harassment, I got paranoid and brought the pictures home in case a janitor found them and showed them to my chairman. See? A perfectly harmless explanation. But then tell him that the exercise was valuable, because I finally was able to tell you what I really want, something I've never told anyone before, that I would like to make love to the accompaniment of my old recording of 'The Teddy Bears' Picnic,' a record that has always turned me on since my nurse used to sooth me to sleep by..."

"Your nurse! What nursery were you ever in? You told me you slept under the kitchen table until you were eleven."

"I'm speaking figuratively. Tell him. It'll keep him happy for days. I'll let you know when he gets around to asking me about it."

"And you really are happy the way we are? You like me as I am?"

"Oh yes. Give me half an hour and I'll prove it. The day I saw you at that party in Cabbagetown, I knew I was doomed. I like it all.

"And the catalogue increases. Something else I realised last week when Arlette was here. You never, ever hang a twenty-pound purse from the corner of my dining chair so that when I stand up to get the salt cellar refilled, I can't move the chair back without first taking off the fucking purse and finding somewhere to hang it, as she should have done in the first place. Somewhere other than the handle of the door of the hall closet."

"Shut up," she said. She was crying. "Shut up and I'll tell you how scared I've been. Now *I'm* going to start here." She kissed my eyebrow and smoothed it round.

"And work down?"

"Depends. Close your eyes."

Nothing happened for a long time. When I opened my eyes she was sitting on the arm of the chair, watching me.

"You're watching me again," I said. "You're supposed to be raising my temperature."

"I know. Close your eyes. I can't talk otherwise. I have to tell you that women are different from men. I am, anyway. I have a different catalogue. Oh, I like the velvety feel of your balls in my hand, stuff like that, but more than that, or just as much, I like watching you from the other side of the street when you don't know I'm there. I saw your face the other day when you were standing at the bus stop in the rain. I thought, he's mine, that one." She paused.

I said, "If you've finished, I've got a suggestion to make."

"Now?"

"Whenever you're ready."

Chapter Twenty-One

THE NEXT day was Saturday and we spent the weekend doing chores. We keep a memo board on the door of the fridge where we list things to be done, from tightening hinges on the kitchen cupboards to cleaning the black stuff off the cracks of the bathroom tile, and then we appoint an occasional day or two to do it, all the way to purging every item of clothing, kitchen equipment, and furniture we have learned to dislike or that no longer functions, every book we never finished, every suitcase that has been replaced by carry-on luggage. We scour the medicine cabinet; we clean out the car, including the trunk. We declare a Mexican New

Year, a time for consuming with fire all the failures of the year be-
fore, and then we don't allow nagging until the notice board is full
again.

We did it all and on Sunday night we watched *Mystery!*, and
went to bed and made love, then turned the lights back on and
read for an hour back-to-back.

~

On Monday morning, Richard's story reached a coda. I arrived at
the office ready to discuss, gleefully, the administration's disarray,
and found Richard looking stricken.

"They always win, don't they?" he said.

It is one of Richard's annoying idiosyncrasies, the habit of an-
nouncing the tragic end of an action as if the listener had been
sharing his life for the last five acts. Thus, if he hears of a plan to
move the English department into the basement and our two
desks into a giant office shared with the janitors, he will greet me
with the statement, "I guess we'd better start saving our quarters."
You then have to patiently trace all the way back, unravelling the
chain, until you learn that what he is saying is that we will no
longer have a place to make a private phone call to bookmaker or
stockbroker or mistress, though neither of us has any of these at-
tachments, and that for all really private calls it will now be neces-
sary to use the call-boxes in the main hall of the college, and for
this we will have to keep a supply of quarters on hand. Thus the
remark really means, "Did you hear we are moving into the base-
ment?"

In the present case, I guessed from the solemnity, even passion,
of his voice, that he was talking about something serious that had
happened to himself.

"In what way?" I asked.

"How many ways are there?"

This was going to be a more than usually difficult one to un-ravel, backed as it obviously was with a ready irritation if I did not immediately know what he was talking about and see the serious-ness of it. Usually I am patient with this side of Richard, because he's a good room-mate, just not perfect. But this morning, having brought him successfully through a medium-sized crisis, then ne-gotiated my own problems until I was in calm water, I wanted a rest. "What are you talking about, Richard? Who are they? What have they won? You can have five minutes before I have to deal with the blinding of Gloucester."

Thwarted of one kind of self-drama, he segued into another, getting up from his desk and crossing the room to the window, then swinging round to face me, like Noël Coward. I saw what he was up to before he swung and I kept my head down, pretending to be searching in my desk drawer, so that he didn't have an audi-ence. He cleared his throat, and I looked up. "They've offered me a job. A full-time, regular, tenured position, beginning at six incre-ments above the bottom."

So he had a right to his gestures. "Starting when?"

"Now." He waved a letter at me. "All very informal, so far, but they mean it."

"Don't worry. Audrey won't let them. She'll insist on our duty to the many good graduates out there." I pointed at the window.

"On the contrary. Audrey is leading the drive to hire me with-out any further interviews. She says, surely the college has a moral obligation to its long-time sessionals."

"Of course. I should have realised. She's scared shitless of your law-suit."

"They all are. One of the conditions is that I drop the charges."

"Turn the job down. Stay where you are."

"If I do that, they'll fire me. See, they've got permission from

the Board to create a new full-time position using the hours I presently teach, plus six from the Extension Division, something they should have done twenty years ago. Under the contract, they have to offer me the next full-time position, but if I turn it down, under the contract I go to the bottom of the list. But by hiring a full-time person for nine or twelve hours a week, they will eliminate one or two part-time positions, the one or two on the bottom of the list. Me. After all these years of publicly demanding a tenure-track position, I won't have a moral or legal leg to stand on if I turn this down."

"And if you proceed with your action after this generous offer, you will clearly be motivated by pure malice or greed. You'll never teach again. You're right, they've won. What will you do?"

"Take the job, of course." He was no longer posing, but in genuine despair. "Now I'll have to finish my thesis, go to the meetings of the Association of Canadian University Teachers of English, find my way around the Robarts Library. Dear God, I don't even know where the rare books room is. And I haven't read a single book or article in my field for about five years. I suppose the buggers will have written hundreds more by now."

"Thousands."

"Don't look so smug, buddy. You're next."

It was true. I was in line now for the next permanent position, and just as keen as Richard had been to stay where I am. "By the way, you said six increments; why six?"

"So they can start me off with a sabbatical. At ninety per cent of my new scale, by the way, to take into account my experience. Stuffing my mouth with gold, they are."

"Well, well. I wonder who they'll put in this office. Did you tell Alice?"

He looked uncomfortable, and said, "Yes."

"What did she say?"

"She already knew. The lawyers worked it out in her office Saturday morning. She thought it was the best deal for me."

"Is she finished with you—the case, I mean?"

"Yes. Both."

"Both?"

"With the case and with me."

I couldn't think quickly of anything to say as I tried to remember if I could have had the slightest hint of a possible connection between Richard and Alice, except from Alice, in confidence. In the end, it came out just right. "You and Alice?" I asked, stuffing the words full of wonder.

"Yeah," he said, and stood there, all poses dropped. "She turned me down."

Now I felt sorry for him. After a while, I said, "You can't win them all, can you?"

He said, "Oh, fuck off."

~

RICHARD KUZNIAK

ABOUT THE AUTHOR

Eric Wright was born in London, England, and emigrated to Canada. After earning degrees at the universities of Manitoba and Toronto, working in construction and as a guide at a fishing camp to pay his way, he became an instructor at Ryerson Institute of Technology in Toronto. There he served as professor, chair of the English department, and Dean of Arts. He began to write, first for periodicals and television, and his first Charlie Salter mystery won the John Creasey Award from the Crime Writers Association of England. Two subsequent mysteries in that series won the Arthur Ellis Award for Best Mystery published in Canada, as did two of his short stories, and he also won the City of Toronto Book Award. Wright has started three other series, and has written a satirical novel, *Moodie's Tale*, about his experiences as a young instructor, and a memoir of his youth, *Always Give a Penny to a Blind Man*.

Canada's most honored mystery writer, Eric Wright retired from teaching ten years ago, but is "still writing novels." He lives with his wife and near his two daughters in Toronto.

MORE MYSTERIES FROM PERSEVERANCE PRESS

Baby Mine, **A Port Silva Mystery**
by Janet LaPierre
The web of small-town relationships in the coastal California village is fraying, stressed by current economic and political forces. Police chief Vince Gutierrez and his schoolteacher wife, Meg Halloran, must help their town recover.

Royal Flush, **A Jake Samson & Rosie Vicente Mystery**
by Shelley Singer
Jake and Rosie infiltrate a dangerous far-right group, to save a good kid who's in over his head. The laid-back California private eyes will need a scorecard to tell the ringers in the gang from the real racist megalomaniacs.

Guns and Roses, **An Irish Eyes Travel Mystery**
by Taffy Cannon
Ex-cop Roxanne Prescott turns to a more genteel occupation, leading a History and Gardens of Virginia tour. But by the time the group reaches Colonial Williamsburg, odd misadventures and annoying pranks have escalated into murder.

Forthcoming in 2001

Blind Side, **A Connor Westphal Mystery**
by Penny Warner
The deaf journalist's new Gold Country case involves the celebrated Calaveras County Jumping Frog Jubilee. Connor and a blind friend must make their disabilities work for them to figure out why frogs—and people—are dying.

The Tumbleweed Murders, **A Claire Sharples Botanical Mystery**
by Rebecca Rothenberg and Taffy Cannon
Microbiologist Sharples explores the musical, geological, and agricultural history of California's Central Valley, as she links a mysterious disappearance a generation earlier to a newly discovered skeleton and a recent death.

Keepers, **A Port Silva Mystery**
by Janet LaPierre
Patience and Verity Mackellar, a mother-and-daughter private investigative team, unravel a baffling missing persons case and find a reclusive religious community hidden on northern California's Lost Coast.

All titles $12.95. Available from your local bookstore or from the publisher at (800) 662-8351 or www.danielpublishing.com/perseverance.